G O Y A

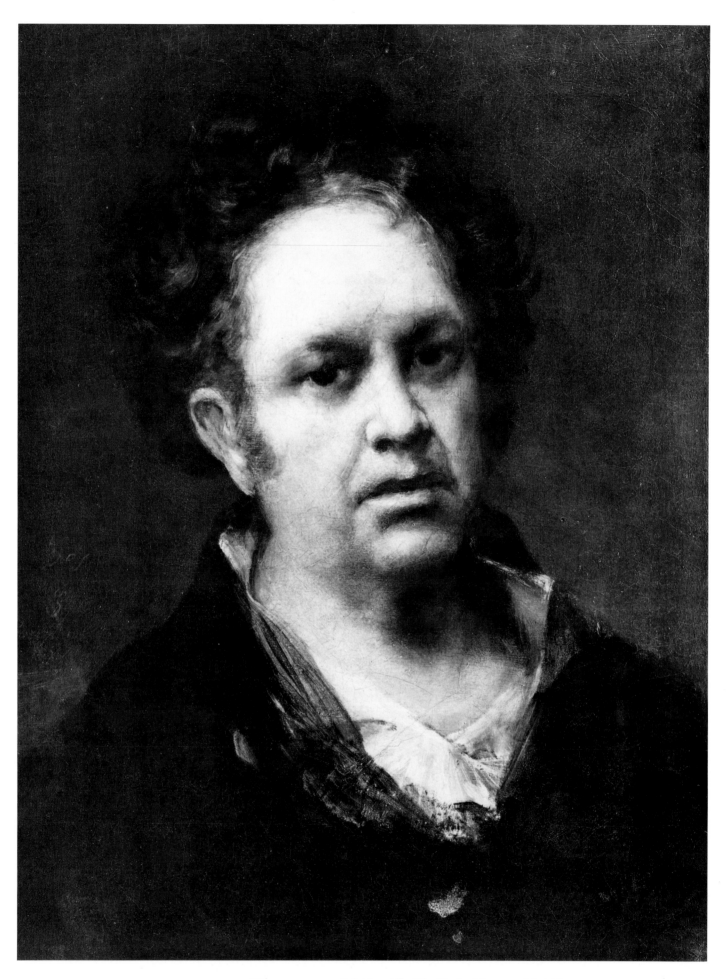

SELF-PORTRAIT. Oil on canvas, 18⅛ × 13¾″. *The Prado Museum, Madrid*

FRANCISCO DE GOYA Y LUCIENTES

GOYA

TEXT BY

JOSÉ GUDIOL

THAMES AND HUDSON

Originally published by Harry N. Abrams, Inc., New York

First published in Great Britain in 1990
by Thames and Hudson Ltd, London

This is a concise edition of José Gudiol's
Goya, originally published in 1964

Printed and bound in Japan

CONTENTS

FRANCISCO DE GOYA Y LUCIENTES was born to Gracia Lucientes on March 30, 1746, in a small house on a narrow and dusty street in Fuendetodos, Spain. The home in Fuendetodos, a poor agricultural village amid rocky hills in one of Aragon's most deserted and dry regions, was temporary, and the great painter's childhood years were passed in Saragossa. There his father, José Goya, had a modest gilder's shop and his grandfather had been a notary, though the origins of the family were Basque. In Saragossa, young Goya attended Father Joaquin's school, where he formed a close friendship with Martín Zapater. The copious correspondence between these two friends, though inadequately published, provides one of the basic sources for our present knowledge of Goya's personality.

Unfortunately, facts relating to the painter's earliest years are not very plentiful. They have been gathered from a spoken tradition, from writings dating shortly after his death, and from casual references in the Zapater correspondence. At thirteen or fourteen, Goya became an apprentice in the studio of José Luzán, a dexterous painter who regularly produced the large religious canvases that were part of ecclesiastical decoration during the final years of the Baroque.

Saragossa, seat of the Archbishopric, was always the artistic center of far-flung Aragon. From hundreds of small towns buyers came to Saragossa's art workshops—as they come even today—seeking sumptuous

1. THE HOLY FAMILY. Before 1771.
Oil on canvas. *Collection Simonsen, Geneva*

2. THE VIRGIN APPEARING TO SAINT JAMES
(detail from Reliquary Cabinet Paintings). *c.* 1763.
Fuendetodos Parochial Church (destroyed in 1936)

decorations for innumerable village churches. The Aragon school of painting provides one of the most interesting and full chapters in the history of Spanish art. Its style is characterized by vigor and by decisiveness of color; the style establishes a somewhat crude, though aesthetically certain, rhythm of form and color which endows the image, and even simple decorative elements, with an inimitable stamp. Goya, who emerged precisely at a crucial moment in Aragonese art—when it had succumbed to the bland mode of provincialized rococo—is in fact universally recognized as the leading exponent of a great school maintained by artists and artisans throughout the centuries. With surprising harmony, the mysterious thread that winds through the distinct art of each locale unites all that Goya produced in his paintings, drawings, and etchings with the severe style of Aragon's medieval masters. It is in a like manner that Picasso represents, in essence, the universal extension of this rough yet sensitive complex which is called Spanish art.

In four years of daily work at Luzán's studio, Goya learned to prepare canvases and colors; he saw how a theme might be developed by combining compositions and figures copied from prints with rough sketches from nature. The endless flow of engravings arriving in large numbers from France, Italy, and Flanders was the effective means by which the representative arts were internationalized; they started an upheaval that finally destroyed the individuality of the minor schools. Hard and monotonous studio work demanding, above all else, rapid production and mastery of the elements of the painter's trade contributed considerably to the development of Goya's superior natural gifts by furnishing him with the basic knowledge necessary to begin as a painter. Very probably the only paintings known to be of this apprenticeship period were those on the wooden doors of a reliquary cabinet in the parochial church of Fuendetodos, destroyed in 1936 (figure 2). Below some hangings supported by angels, these earliest paintings depicted *The Virgin of the Carmen, San Francisco de Paula,* and *The Appearance of the Virgen del Pilar* ("Virgin of the Column"), a pre-eminent Aragonese theme. Goya's iconographically traditional figures reflect Luzán's pictorial formulas in the modeling of light and shade. Even through the distortions (more apparent than real) of the poor photographs available, a notable analytical endeavor is visible. The traditional dating of these paintings in the years preceding Goya's apprenticeship is not acceptable. Sufficient skill required for this work is compatible only with the period of Goya's work in Luzán's studio; thus, the year 1763 is more reasonable as their approximate date.

On December 4, 1763, Goya was in Madrid, participating unsuccessfully in a scholarship competition held by the Royal Academy of Fine Arts of San Fernando. For several years thereafter, no specific references exist concerning the artist's life and work. In July, 1766, young Goya, then twenty, again failed before the Madrid Academy. He did not attain a single favorable vote, despite the presence on the tribunal of Francisco Bayeu, an Aragonese painter established at Madrid. Bayeu, the foremost of three brothers who were painters, was a principal exponent of the aesthetic academicism introduced into Spain by

Anton Raphael Mengs. It seems certain that the first stage of Goya's artistic development took place in Madrid during a period of work with Bayeu. In a letter written at Rome in 1771 concerning a competition at Parma, Goya declared himself Bayeu's pupil. This personal relationship explains Goya's acquaintance with Josefa Bayeu, to whom he was married in 1773, one year before his own establishment in Madrid; she was a sister of the three painters and had lived with them in Madrid.

Gossip and legend had described the youth of the Fuendetodos painter as one devoted to fights, knifings, and romantic incidents; such accounts were enthusiastically collected by Goya's earliest biographers. To moderate this poor reputation, Martín Zapater's nephew published some of Goya's letters to his uncle,

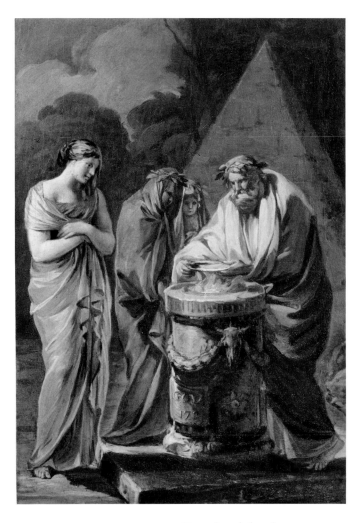

4. SACRIFICE TO VESTA. Signed and dated 1771. Oil on canvas, 13 × 9^1/$_2$″. *Private collection, Barcelona*

3. PORTRAIT OF MANUEL VARGAS MACHUCA (detail). Signed and dated 1771. Oil on canvas. *Collection Bardi, São Paulo, Brazil*

thereby revealing something of the painter's true nature. In point of fact, Goya had an unruly and quarrelsome disposition, a rudimentary education, and a forthright petulance. His youthful letters disclose his great frankness, as well as his affection for bullfights, hunting, and popular fiestas.

Various works have been proposed as indications of Goya's activity during the years between his first trip to Madrid and his stay in Italy; in most instances, these attributions lack stylistic foundation. It is true that the Fuendetodos reliquary cabinet was destroyed before having been adequately studied and photographed. Consequently, reconstruction of Goya's stylistic development prior to works signed and dated in 1771 is most uncertain. Nevertheless, three oil paintings on canvas may with absolute conviction be attributed to him: the small-sized *Holy Family*

9

5. CHOIR VAULTING DECORATIONS (portion). *c.* 1773.
Chapel of the Virgin, El Pilar Cathedral, Saragossa

nied the painting submitted by Goya to the Parma Academy—a lost work, praised by the Parma jury. Signed and dated 1771, the portrait, *Manuel Vargas Machuca* (figure 3), and a pair of small canvases representing scenes of sacrifice to Pan and Vesta (figure 4) were painted by Goya during his visit to Rome. By June, 1771, Goya had returned to Saragossa. In the portrait of 1771, the academic formula is balanced by a certain realistic aura achieved by the smile of the sitter; a skillful *sfumato* ("blending of light and shaded areas") dissolves the linearity, particularly in the face, thus showing that Goya had already initiated one of the pictorial principles that constitute his characteristic manner. The sacrificial scenes take place amid trees, low sunlight producing strong reflections and very fine shadows; the execution is as free and impassioned as that of the later Goya

6. A FATHER OF THE CHURCH (portion).
c. 1773. Wall painting in oil. *Sanctuary of the Virgin of the Fountain, Muel (Saragossa)*

(figure 1) and *Lamentation Over the Dead Christ* (Collection Simonsen, Geneva) and *The Appearance of the Virgen del Pilar* (Collection Quinto, Saragossa). The stylistic relationships of these paintings to those of Francisco Bayeu are obvious, but Goya's demonstrate a keener technique, a superior analytical power, and a richness of color that corresponds perfectly with signed works to be discussed presently. Each figure has an independent nature, as happens in primitive painting, but their sum total is harmonious. The impasto is thick, and the brush strokes render a typically Goyesque liveliness that results from a combination of both vigorous and most subtle touches.

Writing in 1779, Goya declared that while he had been in Rome (in 1771), he had "carried on and lived at his own expense." However, documentary evidences concerning this trip to Italy are few. There is the letter dated at Rome in April, 1771, which accompa-

7. WALL PAINTING (portion). 1774. Oil on canvas. *Church of the Carthusian Monastery of Aula Dei, Saragossa*

paintings less imbued with Neoclassicism. Of excellent workmanship, the scenes employ colors anticipating the original manner which is typical of Goya's mature works.

That Goya was established as an independent painter in Saragossa by 1771 is corroborated by his tax declarations. It seems probable that the wall paintings in oil for the chapel of the Sobradiel Palace, owned by the Counts of Gabarda, were among his first works in that city. The compositions were most probably dictated, since the *Visitation, Dream of Saint Joseph,* and *Burial of the Saint* were almost wholly copied from engravings by Vouet and Maratta. The small *Saint Anne, Saint Vincent Ferrer, Saint Cayetano,* and *Saint Joachim,* which complete the series, seem to

be original. The tactile quality of a certain flame-like form, notable in the folds of the fabrics, somewhat detracts from the dramatic effect. In technique, a joy in the pictorial material and in workmanship itself are already indicated. In the separate images a taste for the emotional appears with great intensity.

These paintings, and other works now lost, occupied Goya's initial months at Saragossa. However, it was not long before he obtained an important commission, the decoration of the choir vaults of the stately chapel of the Virgin, designed by Ventura Rodríguez for the great basilica of the Virgen del Pilar. This project offered Goya an opportunity to prove his knowledge of the fresco technique. By January, 1772, a large sketch, *The Adoration of the Name of God by the Angels,*

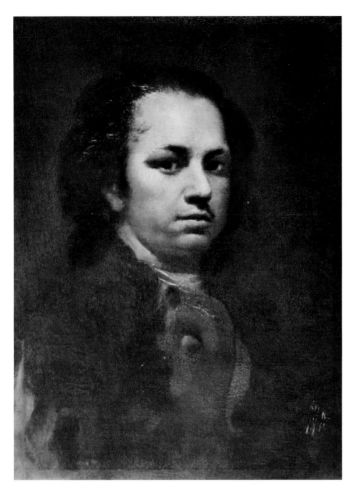

8. SELF-PORTRAIT. *c.* 1774. Oil on canvas.
Collection Marquis of Zurgena, Madrid

9. THE VISITATION (detail). 1777. Oil sketch
on paper, 26³/₈ × 18¹/₂″. *Collection G. Ricart, Barcelona*

was completed. The fresco, which follows the sketch exactly, was finished in June of the same year (figure 5). Here may be seen the first culmination of Goya's art, achieved by means of skillful effects of light and a boldness of technique. Far from simply following methods learned at Madrid, Goya improvised new solutions to suggest form, movement, and space, in a manner probably derived from his Italian experience.

Study of the sketch on which Goya worked for two months is instructive for an understanding of his stylistic development. Overpaintings and revisions reveal the great analytical power developed by Goya, surpassing the stereotyped formulas of Baroque decoration. Extremely complex planning of opposing lights, and the violent impact of direct lights and bold reflections, disclose his desperate seeking for the elements necessary to materialization of the idea. Goya balanced the light in his painting to suggest the

contrast between the illumination of his subject and the rays of daylight which streamed into the choir through the large windows.

In proportion to Goya's enormous capacity for work and the untiring productive rhythm sustained throughout his life, only very few works are identifiably of this period. Unprejudiced analysis of paintings attributed to Goya and his contemporaries in Saragossa would be useful and perhaps surprising in its results. It is difficult, for example, to accept the almost complete loss of lesser works that Goya could have executed during his youth. Several paintings which are undoubtedly related are: two small sketches at the Saragossa Museum; a portrait, *Man with Hat*, also at the Saragossa Museum; and two series of *Fathers of the Church* painted for churches at Muel (figure 6) and Remolinos. These series were based on a single set of sketches, though in each instance Goya introduced

modifications for their adaptation to the structure of each building. At Remolinos, the paintings are in oil on canvas. Those of Muel were executed in oil, but on the walls. The technique is based on a superimposing of simple values, permitting rapid modeling of forms and chiaroscuro (light and shade). Initially, these compositions were set forth in very fluid earth colors and dark tones. Final modeling and finishing touches—in ochers, whites, vermilions, blues, and blacks—were savagely applied in strokes of exaggerated impasto. The procedure Goya employed paralleled that of the preparatory sketches then so useful to Spanish painters, drawn in black-and-white on dark paper. We observe that Goya from the beginning employed a technique of synthesis which in other artists constitutes a sign of maturity. For this reason, there is basically little difference between the stirring Remolinos paintings executed before the age of twenty-eight and those of the Quinta del Sordo (House of the Deaf Man), which Goya painted in his seventies. The

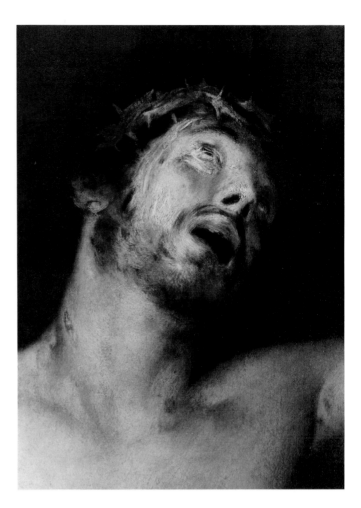

11. HEAD OF CHRIST (detail from the CRUCIFIXION). Presented by Goya to the Academy of San Fernando in 1780. Oil on canvas, 100 × 60¹/₄″. *The Prado Museum, Madrid*

10. THE CROCKERY SELLER. Delivered in 1779. Tapestry cartoon, oil on canvas, 102 × 86⁵/₈″. *The Prado Museum, Madrid*

differences are not fundamental, but are the evidence of life's hard lessons, of literary influences, and of experience acquired in an exalted labor.

On July 25, 1773, Goya and Josefa Bayeu were married in Madrid. However, Goya could not have been absent from Saragossa for any length of time, since his name appears without interruption in the city register of artisans' contributions. It was precisely after his marriage that Goya completed the extraordinary wall paintings of the Carthusian monastery of Aula Dei in Saragossa (figure 7). From data gathered by Fray Isidoro Maria Estudillo, it is now known that the paintings were executed between April and November of 1774. One is astonished, even considering Goya's talents as a creator, that in only seven months he could have completed eleven compositions, each of which averages about 250

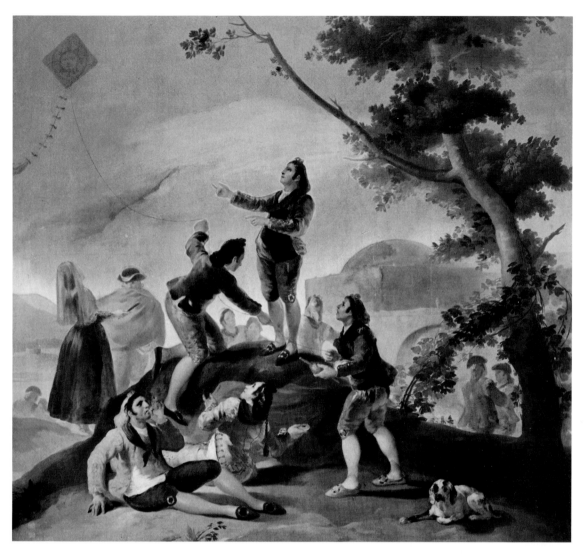

12. THE KITE. Delivered in 1779. Tapestry cartoon, oil on canvas, 106 × 113".
The Prado Museum, Madrid

square feet. A particularly rapid technique was used, modeling with light strokes on a dark ground, suggesting effects with the fewest possible elements, and absolutely dispensing with any insistence on labored brush strokes. The first period of Goya's art culminates in these paintings.

1775–92

Goya states in one of his writings that he was called to Madrid at the close of 1774 by Anton Raphael Mengs, who wished him to paint cartoons for the Royal Manufactory of Tapestries. It was most probably Francisco Bayeu who agreed, at the urging of his sister Josefa, Goya's wife, to employ the painter in the execution of work at the Royal Manufactory. Actually, the twenty-eight-year-old Goya had already achieved artistic success before he left Saragossa. As

fiscal records of that city prove, Goya had attained in three years of work the highest level among tax-paying painters, surpassing in income even his own master, Luzán, and the old Mercklein, Francisco Bayeu's father-in-law. A self-portrait of this period— the earliest known—shows us Goya's optimistic appearance, and reflects health and prosperity (figure 8). It is painted with simplicity and candor, as if to suggest the maturing of his faculties and the inner satisfaction derived from his great work for the Aula Dei monastery. In Madrid, the young husband lodged in Bayeu's house, and there his first son, baptized on December 15, 1775, was born.

In an admirable book, Valentin de Sambricio has published a critical and documented study of Goya's participation in the works of the noted Royal Manufactory of St. Barbara. It was this establishment which

provided the innumerable tapestries decorating the royal palaces and residences. Almost all of the cartoons executed there are preserved—the majority in the Prado Museum at Madrid—as are also the complete documentary references concerning each painter's contribution to this work. The Royal Manufactory of Tapestries, together with other manufactories similarly established, was the most important bequest of the Bourbon rulers to the development of Spanish art. Goya's first undertaking, in May, 1775, consisted of five cartoons. They demonstrate so submissive and mediocre a style that, prior to Sambricio's investigations, none was attributed to the Fuendetodos master. A rapid recuperation of Goya's own personality is manifested in four canvases painted during the second half of the year. Yet they, and others, remain considerably distant from the Aula Dei paintings, and even from the small religious scenes of 1771 mentioned earlier. The change from the freedom that Goya had enjoyed in Aragon to the rigid discipline of work under Bayeu clearly created a feeling of inferiority from which Goya did not fully recover until the relationship was violently broken six years later.

It may be suspected that Goya really was always weak—firm in his art, but insecure in his relationships with the outer world. Despite his achievements, there may be continuously glimpsed the reactions, of a timid man, governed by emotion and somewhat lacking in self-confidence. From the misery surrounding his childhood, he always retained a chronic fear of poverty. Thus, he was constantly more preoccupied with small professional rivalries and economic problems than with the conception of a work of art. However, his art was effortlessly produced, he brought to the creative process simply his instinct and the nimble hand that painted with miraculous synchroni-

13. REGINA MARTYRUM (portion). 1780–81. Cupola fresco. *El Pilar Cathedral, Saragossa*

zation the products of his imagination and his aesthetic purpose. With little experience and counsel, he was able to paint the 900 square feet of the Pilar fresco in four months—and in slightly more time, the enormous Aula Dei compositions. In both works, improvisations, discoveries, and rewards came to him, in contrast to the earliest cartoons, plagued with the hesitations of an apprentice. The gap in quality between Goya's Aragonese paintings and the insufficiencies of his early Madrid works fully justifies the lack of interest of historians in whatever he accomplished before putting his brushes to the service of the Crown.

A single cartoon of 1776, *The Picnic*, leads one to expect that Goya would begin working in accordance with his capability. One of his earliest Madrid works, the *Portrait of the Count of Miranda* (Lázaro Museum,

Madrid), was painted in 1774; in it is exhibited the porcelain-like finish that had been imposed on court circles by Mengs. The live flame of Goya's creativity, almost freed of the yoke imposed by the cartoons, may be seen in a small group of paintings produced in 1777. These include an additional version of the scene representing Aragon's patron, the *Virgen del Pilar* (Collection Muñoz, Barcelona), a very beautiful study of *The Visitation* replete with nostalgic reminiscences of the Aula Dei paintings (figure 9), a *Saint Peter* (Collection Marquis of Casa Torres, Madrid), a pair of small religious pictures at Valencia's Cathedral, and a *Saint Barbara* (Collection Torelló, Barcelona). All of these paintings were for clients of modest means or for friends from Aragon living at the Madrid court.

Goya's self-confidence is seen reborn in five cartoons commissioned in 1777. Notable accents were attained in *The Maja and the Cloaked Men*, and particularly in *The Parasol* (page 49), one of the most popular of Spanish paintings. During the following year, Goya continued producing cartoons, earning for five commissioned between January and April a sum equivalent to his income of the entire preceding year. After an interruption due to illness—known through the letters to Zapater—Goya resumed work for the Royal Tapestry Manufactory, delivering several compositions at the beginning of January, 1779. Among these was *The Crockery Seller* (figure 10), which, together with *The Kite* (figure 12) and *The Blind Guitarist*, is with reason numbered amongst the best of Goya's cartoons. The painter continued to devote his efforts completely to the cartoons. Late in January, 1780, Goya was able to deliver eleven cartoons; outstanding among these were such interesting works as *The Washerwomen* (page 51), *The Bullfight*, and *The Doctor*. With this group, the first cycle of Goya's collaboration with the royal factory came to an end, the Crown necessarily discontinuing its extravagances in order to support the war against England. In compensation for his work, Goya was elected a member of the Royal Academy of Fine Arts of San Fernando. In accordance with its rules, he presented to the Academy the painting *Crucifixion*, a work that unjustly earned abundant adverse criticism (detail, figure 11). Actually, Goya had intended to create a

14. PORTRAIT OF CANON PIGNATELLI (detail of study). 1780–81.
Oil on canvas, 31^1/$_2$ × 24^3/$_8$".
Collection Duke of Villahermosa, Madrid

work strictly within academic canons, and had made use of an example by Bayeu, itself a servile transcription of a Mengs *Crucifixion*. However, even in this effort Goya not only surpassed those who were, academically speaking, his acknowledged masters, but he successfully added an original expressiveness to the head of Christ, in perfect accord with the best of his own style. A replica of this *Crucifixion* by Goya's own hand is in the Toledo Museum.

Collaboration in Crown undertakings offered Goya an opportunity to study the superb royal collections; thus he came to know the art of Velázquez. In 1778, Goya sent a series of etchings reproducing paintings by the great seventeenth-century artist to his friend Martín Zapater. Arbitrary interpretations and abundant, evidently involuntary transformations of facial features produce an aspect of fantasy, anticipating works of Goya's old age. These modifications must also have been the cause of the economic failure which Goya encountered with this series, the first he intended for publication. These unfortunate plates reveal—as do the earliest tapestry cartoons and the Sobradiel Palace paintings at Saragossa—Goya's inevitable failure when obliged to copy in a servile manner the work of others.

The impact of Velázquez's pictorial conception is, however, immediately reflected in Goya's tapestry cartoons. In those of small format, particularly in the series dedicated to children's games, he used lengthened brush strokes and a color density appropriate to the form. In large compositions he acquired a permanent mastery of atmospheric effects and discovered the pictorial value of reflected light. He was able to adapt, as had no other painter, the discoveries of the great seventeenth-century master. In a later period, Goya would succeed similarly in enriching his technique by adapting certain of Murillo's misty vibrations.

Goya again lived in Saragossa between October, 1780, and June, 1781. The Council of Works of El Pilar Cathedral had recalled him from Madrid to participate in their program of decoration. Oil sketches and the final cupola fresco dedicated to the *Regina Martyrum* (figure 13) were painted by Goya, as were four allegorical figures of the *Virtues*, placed in the triangular spaces formed by the arches. The latent

15. SCENE WITH VARIOUS FIGURES. 1780–81. Oil on canvas. *Aragonese Society of Friends of the Country, Saragossa*

argument between Goya and his brother-in-law, Francisco Bayeu, broke out with violence during execution of these works. Bayeu had been assigned the painting of the other cupola, and was officially regarded as director of the entire decorative scheme. The sad result of their conflict was that Goya lost the commission; he was obliged to humiliate himself, to present new sketches for the triangular units, and,

17

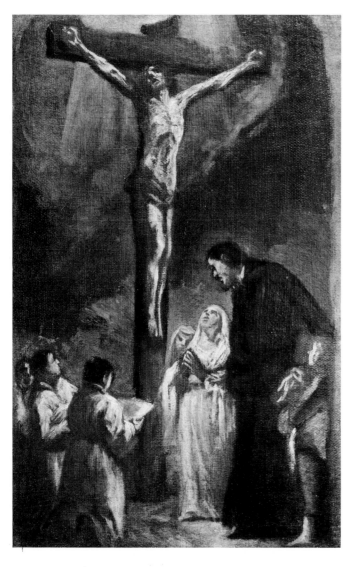

16. SAN JOSÉ DE CALASANZ BEFORE THE CRUCIFIXION. 1780–81.
Oil on canvas. *Collection Berriz, Saragossa*

realism of the sketches. The figures maintain the heroic canon that Goya preferred. However, in the synthesis of the Baroque and ideal Neoclassicism, an almost caricature-like aspect is occasionally intermingled. This occurs in the exaggeration of details and in the tragic quality of some heads and faces whose irregular outlines are one of the frequent traits of Goya's expressionism. Improvisation and an interest in brush stroke, traces of line, and pictorial material are continuously noticeable. The intensity of these characteristics is such that the protests of Bayeu and Goya's more academically minded contemporaries are understandable. Realizing the uncertain nature of his work at Madrid, Goya probably used his stay at Saragossa to resume contacts. Thus, as evidences of this period, the following works may be proposed: a study for the lost *Portrait of Canon Pignatelli* (figure 14), an enigmatic sketch of figures at the Aragonese Society of Friends of the Country (figure 15), and an impressive sketch, *San José de Calasanz Before the Crucifixion* (figure 16), which justifies Goya's famous declaration acknowledging Rembrandt, Velázquez, and Nature as his masters.

Early in July, 1781, Goya was again in Madrid, though without definite work at the Royal Tapestry Manufactory and without other known commissions. To the hardships of his struggle for existence were added the painful memories of Saragossa and the intrigues of colleagues envious of his rising prestige. Goya's frequent letters to Zapater offer a very valuable reflection of this crucial period. Soon, however, it was succeeded by one devoted to the painting of religious themes and portraits. On July 25, Goya wrote his faithful friend about a large painting commissioned for the church of San Francisco el Grande in Madrid. This commission was also, however, simultaneously assigned to several rival colleagues. Thus his victory in the resultant competition, publicly judged in October of 1784, was considered by Goya as his first success at the Madrid court.

Three preparatory sketches show the evolution of the work that depicted *The Sermon of Saint Bernard of Siena Before the King of Aragon, Alfonso V* (figure 17). The final canvas conforms somewhat to academic tastes. Goya took cognizance of his recent failure at

finally, to renounce his collaboration in what might have been the most important artistic undertaking of his native region.

In spite of the frequent restraints imposed by his troublesome brother-in-law, Goya kept in mind the deformations to be produced by distance, simplifying his forms and accentuating the dominant features. Nevertheless, this was probably less intended to ease the spectator's task than to gratify Goya's own passion for bold technique, as he experimented with daubs of color, rough sketchings, mere traces of line, almost dissolved forms, and modified proportions. And despite this technique—rich in expressive meaning, irregular, and most personal—the general appearance suggests idealizing, on comparison with the sharp

Saragossa, and here fails to demonstrate the qualities attained in the works of the Pilar and the Aula Dei. Goya himself is included in the audience of saintly figures; as a preparatory study, he painted the impressive self-portrait now at the Agen Municipal Museum.

During this most vacillating period of his career, Goya alternated the execution of this laboriously elaborated official work with various other paintings. The latter remain unidentified, since the number of recognized works of this period are insufficient to represent adequately the production of an artist of Goya's capacity. A portrait of the director of the tapestry manufactory, *Cornelius van der Goten*, was painted in 1781. The very much disdained Goya painting, *The Holy Family* (Prado Museum), disclosing the influence of Mengs, might, on the basis of its style,

be assigned to this period. The large *Portrait of the Count of Floridablanca* was painted by Goya in 1783 (page 53). The figure, seen full length in a rococo setting, is accompanied by his secretary and by the painter himself, who offers a small canvas to the Count. The work is ambitious and has excellent passages. It is not without fault, but the preoccupation for accommodating the taste of others, noted in the painting then being completed for San Francisco el Grande, begins to give way. It might therefore be inferred that the portrait was not to the liking of the powerful minister, who paid Goya with unfulfilled promises.

In this same year, Goya enjoyed some weeks of happiness at Arenas de San Pedro, Avila, having been invited there by the Infante Don Luis. This unfortunate brother of King Charles III, who had renounced both the cardinal's biretta and the bishop's miter at Toledo, lived in Arenas de San Pedro apart from the court, following his marriage to Doña Maria Teresa Vallabriga, an Aragonese lady. Goya's letters of this time to Zapater reflect the bucolic setting. However, it is certain that he worked steadily, painting at least six portraits and an additional large composition of the Infante's family. In this family portrait, the wife of the Infante is seen attended by her hairdresser and is surrounded by her husband and children, the majordomo, and other servants. In the foreground, Goya portrayed himself in the act of painting. This very interesting work (Collection Ruspoli, Florence) is not generally accessible but is known from a smaller copy. However, three of the portraits executed in Arenas de San Pedro are available. In the portrait of the Infante, Goya drew nearer than ever to Mengs's pictorial conception, though he clearly surpassed Mengs in psychological insight and in technique, successfully giving preference to visual, rather than tactile, realism.

Even more interesting is the portrait of the Infante's wife (figure 18), executed with complete freedom, since Goya had had to paint it in very few sessions. In this portrait, Goya found his own direction. However, if considered as the starting point of a gallery of superb, pure Goya portraits, that of the Infante's wife does not appear exaggeratedly free. It possesses qualities identical to those seen in the por-

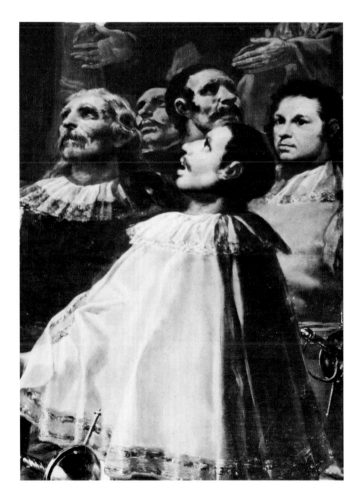

17. THE SERMON OF SAINT BERNARD OF SIENA
BEFORE THE KING OF ARAGON, ALFONSO V (detail).
1783–84. Oil on canvas, 169 × 118″.
Church of San Francisco el Grande, Madrid

trait of the two-year-old future Countess of Chinchón and wife of Godoy, shown in an early portrait before a landscape background which apparently was taken from one of Goya's tapestry cartoons (figure 19). The remaining portraits Goya painted during this short summer period are not known to us, though they included a profile-bust portrait of Don Luis on the reverse of which Goya wrote "painted . . . from nine to twelve on the morning of September 11."

Goya was back in Madrid by September 20, before public presentation of the painting for San Francisco el Grande, noted earlier. No documentation concerning other works Goya painted at this time is known.

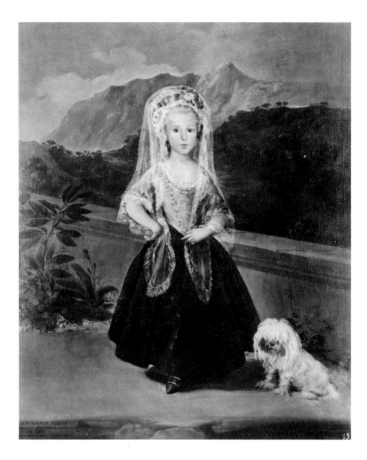

19. PORTRAIT OF MARÍA TERESA DE BORBÓN Y VALLABRIGA, COUNTESS OF CHINCHÓN. 1783. Oil on canvas, 52⁷/₈ × 46". *National Gallery of Art, Washington, D.C.*

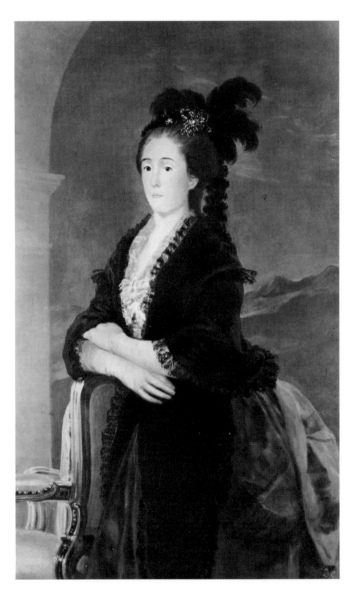

18. PORTRAIT OF MARÍA TERESA VALLABRIGA. 1783. Oil on canvas. 76³/₄ × 51¹/₈". *Collection Ruspoli, Florence*

However, these might have included the exceptional full-length self-portrait in which Goya's hatted figure is vigorously silhouetted against the light (figure 20). Goya's son, in later describing this painting, included a special discourse on the painter's use of controlled candlelight, which enabled him to paint at night. In 1784, with the aid of Jovellanos, Goya received a commission for four canvases—now lost—for the Colegio de Calatrava at Salamanca. Also dated 1784 are an ironic representation of *Hercules and Omphale* (Collection Duke of San Pedro de Galatino, Madrid), a portrait of the boy *Vicente Osorio* (Collection Payson, New York), and that of *Ventura Rodríquez* (National Museum, Stockholm). It was during this same year that Javier Goya was born, the son who would carry on the name of the great painter.

In 1785, Goya obtained the modest position of Deputy Director of Painting at the Academy of San Fernando. Little by little, he penetrated into the wide

world of Madrid. Ceán Bermúdez provided him with a commission to portray *Don José de Toro y Zambrano* for the Bank of San Carlos; other portraits soon followed (Bank of Spain, Madrid). For the ducal house of the Medinaceli he painted a large *Annunciation*, the sketch for which (Collection Wildenstein, London) is a milestone in indicating a movement toward simplification of structure and color within Goya's rapid career. In works of this optimistic period, a slight change of palette is visible, and smooth, melting shades of color are sought. The outstanding *Portrait of the Duchess of Osuna* (Collection March, Palma de Mallorca) is a true masterpiece of Spanish portraiture, with which the portraits *Gasparini* and the *Count of Gausa* must be contemporary.

In 1786, Goya again undertook the execution of tapestry cartoons. In this new phase he worked with increased independence, giving greater importance to landscape, lighting, and surroundings, while sharpening feeling for the narrative and the real. However, he did not completely abandon conventional canons, deferring partly to the taste of those who commissioned the designs and partly to the limitations imposed by the rudimentary tapestry-weaving technique. Indeed, the weavers protested against complications caused by variations in tone and the excessive fluidity of manner in Goya's original compositions.

Resumption of work for the Royal Tapestry Manufactory earned for Goya the title of Painter to the King. Of the cartoons produced during this year, *The Flower Sellers*, the topical *Wounded Mason*, and particularly *The Snow* (figure 21) are outstanding for the realistic lighting of the surroundings Goya effected. Several portraits of 1786 are known, including *The Count of Altamira*, *The Marquis of Tolosa*, and *Charles III* (Bank of Spain, Madrid), as well as the *Mariano Ferrer* and *Francisco Bayeu* (Museum of Fine Arts, Valencia). In the Valencia portraits, somber hues presage the sobriety of Goya's later works.

During the year that followed, Goya delivered three paintings for the Church of Santa Ana in Valladolid. These pictures remain in the church, where they face three others of identical size by Francisco Bayeu. The aesthetic distance between the Goya and the Bayeu series is so great that, even without knowing the judg-

ments of the period, it may be supposed that the older, academic brother-in-law would have been considered the inferior artist in this second encounter between the two rivals. Before Bayeu's saccharine, affected images, Goya presented, in his *Saint Bernard Baptizing a Kneeling Man* (page 55), strongly interacting whites that approach in quality those by Zurbarán; in the sad *Death of Saint Joseph* scene, he attained passionate iridescences similar to those of Murillo. Indeed, all of this was certainly accomplished purely by instinct, for despite a renewed regard for Andalusian painting at the court—to which many examples were brought as a consequence of the personal preferences of Isabel Farnese, wife of Philip V—it is improbable that Goya had occasion to become acquainted with it. During

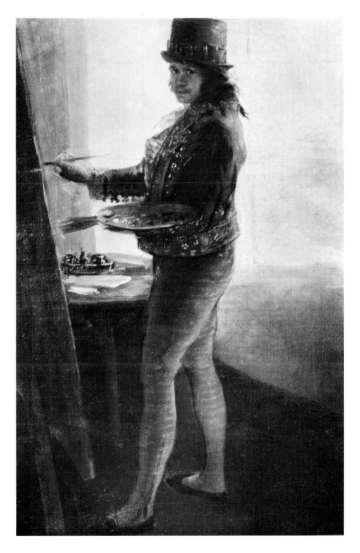

20. SELF-PORTRAIT. c. 1784. Oil on canvas, 16$\frac{1}{2}$ × 11".
Collection Count of Villagonzalo, Madrid

1787, Goya also painted seven compositions for the Alameda, home of the Dukes of Osuna; genre scenes similar to those of the tapestry cartoons were represented. Freed of the limitations of the weaving technique, Goya's iridescent colors were enriched, and the entire decoration was executed with greater spontaneity. In these ornamentations in the French mode, the themes narrated take on a gay tint, like that of comedy scenes—even in the tragic *Assault on the Stagecoach*. The kaleidoscopic quality and the great sensitivity of these paintings is demonstrated in the beautiful *Portrait of the Marquesa de Pontejos*, justifiably often favorably com-

pared with the best of eighteenth-century English painting (page 57).

In June, 1788, Goya experienced a disheartening defeat at the Academy on not obtaining even one vote for the office of Director of the Division of Painting. As in the competition of 1766, another painter, Gregorio Ferro, of no significance in the history of Spanish painting, won over Goya. This result must not be considered as an unfavorable judgment of the accomplishments of Goya by his contemporaries but rather as an expression of resentment by the mediocre of the superior. Preparatory sketches for most of

21. THE SNOW. Delivered in 1786. Sketch for tapestry cartoon, oil on canvas, 12¹/₂ × 13″. *Collection Silbermann, New York*

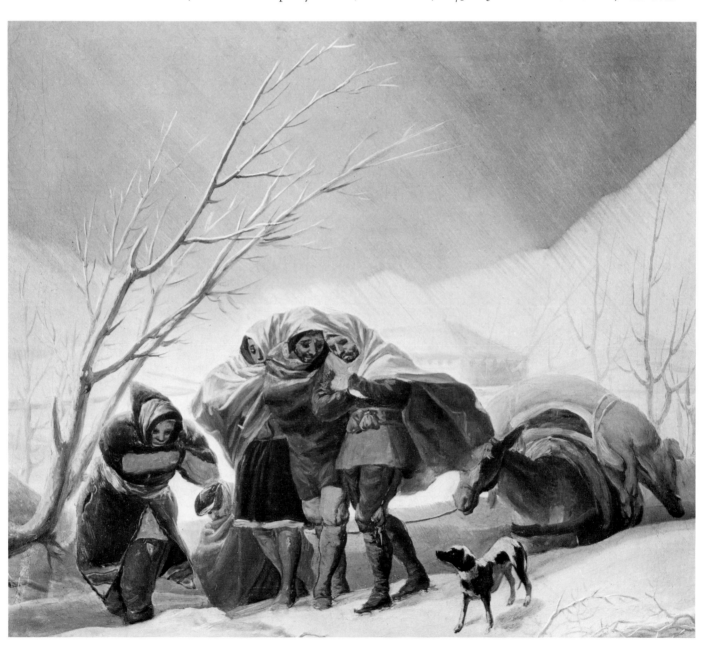

Goya's tapestry cartoons of 1788 remain; outstanding is the often-published *Meadows of San Isidro*, mentioned by Goya in his letters to Zapater as one of his major pictorial preoccupations. During the year, Goya also delivered the Valencia Cathedral's large canvases dedicated to exalt the veneration of St. Francis of Borgia. These theatrical compositions were painted more with determination than with enthusiasm. Nevertheless, passages of great quality were achieved, as in the familiar scene of the Saint's farewell. Shades of emotion and mystery are attained in the scene of a dying man surrounded by monsters and aided by the Saint, the first of Goya's hallucinatory series of paintings (page 59). During this period of intense activity, compositions and portraits alternated in Goya's œuvre. There filed past his palette *The Countess of Altamira with Her Daughter* (Collection Robert A. Lehman, New York), *The Count of Cabarrús* (Bank of Spain, Madrid), and the child, *Don Manuel Osorio de Zuñiga* (The Metropolitan Museum of Art, New York [page 61]).

Charles IV was proclaimed king on January 17, 1789. On April 25 of the same year, Goya was granted the title, Painter of the Royal Household. Thus his position as portraitist to the royal family and to the court was made secure. The painter sought to adapt himself to this role, subduing his temperamental rudeness and trying in his own way to "maintain a determined idea and preserve a certain dignity which man must possess." Overwhelmed with work, since he had to paint rapidly many portraits of the new monarchs, Goya sought to escape little by little from his obligations to the Tapestry Manufactory. This he did to such an extent that the official records for 1789 note only a single cartoon by Goya, the very beautiful *Blindman's Buff*. The *Portrait of Juan Martín de Goicoechea* is apparently of this same year. For stylistic and historical reasons the following portraits may also be considered contemporary: *Ceán Bermúdez* and *The Wife of Ceán Bermúdez*, the bullfighters *Pedro Romero* and *Costillares* (Taft Museum, Cincinnati), *The Marquis of Bajamar* and *The Marquise of Bajamar*, *The Countess of Casa Flores* (Museum of Art, São Paulo), and *Luis de Urquijo* (Academy of History, Madrid). The masterpiece of this period is the portrait *The*

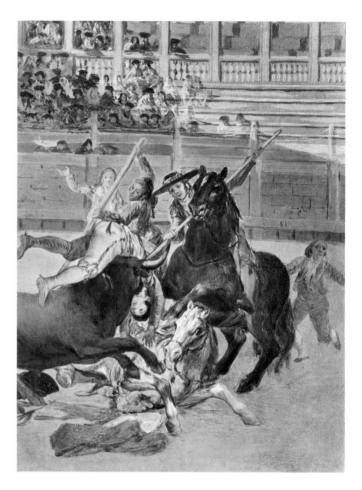

22. DEATH OF A PICADOR. *c.* 1788. Oil on tin plate, $16^7/_8 \times 12^1/_4''$. *Collection Cotnareanu, New York*

Duke and Duchess of Osuna with Their Children (page 63), a symphony in grayish-blues and one of the best Goya paintings in the Prado; it is completely original, and in it Goya approaches the misty textures of Murillo, reflected in modern times by Renoir. Between August and October of 1790 Goya was in Valencia, where he was made a member of the Academy of San Carlos. While there he apparently also painted some portraits, among them the *Joaquina Candado* at the Museum of Fine Arts in Valencia. From Valencia, Goya passed to Saragossa, where he painted the portrait of his faithful friend, *Martín Zapater*.

When trying to place in order all the Goya paintings, one observes a tendency to construct various series of compositions, interrelated in subject, format, and technique, since each group would have been created within a short period of time. This predilection for building series results from various factors common to several examples of Goya's art: (1) an innate

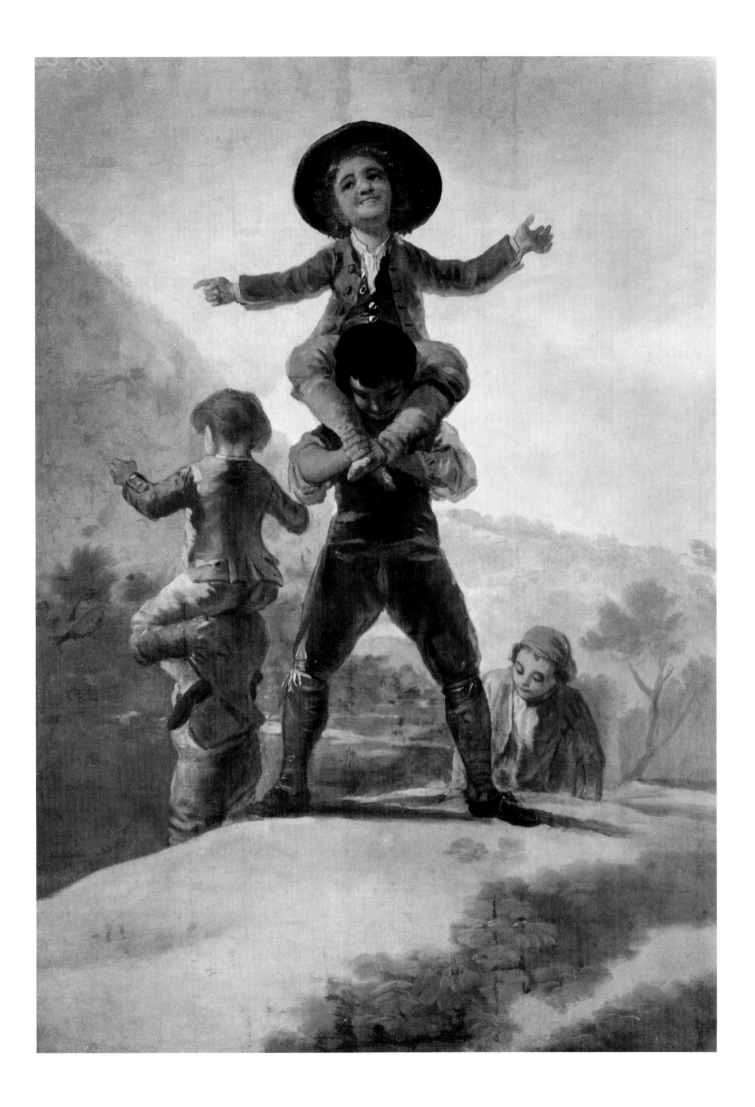

narrative tendency based in popular tradition and in medieval art, perhaps strengthened by Hogarth's examples that were possibly known to Goya through prints; (2) an attraction for the general, human element, always conceded as much importance by Goya as the strictly aesthetic; and (3) an economic motivation, which also turned Goya toward etching and lithography. Within the format of the series, Goya found the most fitting application of his descriptive talent, which united the dramatic and the satiric, the realistic and the imaginative.

Diverse childhood scenes are the subject of what, on the basis of stylistic analysis, is regarded as Goya's first pictorial series. Curiously, this series supports our thesis concerning Goya's economic motivations, since the scenes are repeated in other parallel series—truly replicas—each composition coinciding to such a degree that all must have been obtained through following a single set of drawings. The most complete group consists of six compositions (Collection Duke of Santa Marca, Madrid). The subjects include *The Swing, Playing at Soldiers, The Robbery of the Nest, Playing at Bullfighting, Children Begging Money,* and *Children Jumping.* The technique coincides with that of the tapestry cartoons of 1786; especially useful for comparison is the 1786 cartoon *The Harvesters,* which includes children together with farm workers. Architectural settings in the background provide the only reference to space and surroundings.

The same unity of theme and format is present in a group of pictures based on a Spanish subject par excellence, bullfighting. The subject is one that lends itself exceptionally well to treatment in a series. The group is comprised of seven known compositions: *Capture of a Bull, The Banderillas, The Bullfighters' Troupe Clearing the Ring, Fighting with the Cape, Death of a Picador* (figure 22), *The Killing,* and *The Dragging Away of the Bull.* The first two scenes take place before an enclosure improvised with a barrier; the other five show the inside of a bull ring with rows of seats and galleries.

OPPOSITE: 23. PLAYING AT GIANTS. Delivered in 1791.
Tapestry cartoon, oil on canvas, 54 × 41″.
The Prado Museum, Madrid

24. THE LAST SUPPER (detail). *c.* 1792.
Oil on canvas. *Santa Cueva, Cádiz*

The technique of these paintings matches that distinguishing the tapestry cartoon sketch inspired by *The Meadows of San Isidro.* We may therefore consider the bullfights to be of about 1788. Multitudes are suggested by summary brush strokes, not specific in definition of forms but very precise in distribution and tone. Chiaroscuro is rendered with a certain exactness, above all in the modeling of the figures occupying the arena. An increased interest in tactile qualities is noticeable, heightened by the contrast between the lustrous skin of the bulls and the rich ornamentations of the bullfighters' costumes. In the *Death of a Picador,* repertorial accuracy and improvisation are apparent. This feature is later developed by Goya in paintings like *The Fight Against the Mamelukes.* Noticeable in almost all paintings of the bullfight series is a certain preciosity characteristic of the miniaturist. In the series, Goya gave full expression to the aphorism coined by him: "My brush must not see more than I."

25. THE SHIPWRECK. *c.* 1793. Oil on tin plate, 18$\frac{1}{2}$ × 12$\frac{3}{4}$″.
Collection Marquis of Oquendo, Madrid

26. BANDIT STABBING A WOMAN. *c.* 1793. Oil on canvas,
16$\frac{1}{2}$ × 12$\frac{5}{8}$″. *Collection Marquis of La Romana, Madrid*

Goya's work for the Tapestry Manufactory did not cease completely until 1791, after the delivery of seven final cartoons. Some of these, such as *The Scarecrow*, have become famous more for their themes than for their quality. They are surpassed by others less well known, for example, *Playing at Giants* (figure 23), a work that measures up to the best produced by Goya during this period of unqualified success. The painter's life and work during 1792 remain somewhat unclear. The only painting certainly of this date is the magnificent *Portrait of Sebastián Martínez* (page 65), painted in a range of bluish-grays almost identical to those again used in one of Goya's last canvases, the admirable *Milkmaid of Bordeaux* (page 127). It may be that the Martínez portrait was painted during Goya's stay in Cádiz. Goya's trip to this seaport in Spain's Southwest was motivated by his work on three large canvases, depicting scenes from the life of Christ, for

the Cádiz Oratory of the Santa Cueva. The extended format of the paintings was the source of multiple pictorial difficulties, which Goya resolved, however, with his habitual, and always surprising, originality (figure 24).

It is known that in January, 1793, Goya was granted permission to go to Andalusia to recover his health. He had been in Cádiz, apparently in Martínez's home, when the unfortunate illness that brought him near death overtook him. Slightly later, Zapater speaks of Goya's disease in a letter to Sebastián Martínez; a letter by Martínez, dated March 19, stipulates that Goya's illness was localized in the painter's head. Goya recuperated slowly from this unidentified affliction that, according to the painter's later statements, produced great noises in his head; what is certain, however, is that when the illness abated, Goya was left totally deaf.

Gómez Moreno has pointed to Goya's illness in Cádiz as one of the crises that imposed character on the painter's life and work. The deafness, which from then on limited his contact with the human world, both accentuated his propensity for the fantastic and prodded his tendencies toward the dramatic and the visionary. Goya himself says this in the famous letter to Bernardo de Iriarte which accompanied eleven pictures presented to the Academy in 1794. Actually, it is not known which of Goya's paintings at the Academy were those executed, in his own words, "to occupy my imagination, vexed by consideration of my ills, and to . . . make observations that normally are given no place in commissioned works where caprice and invention cannot be developed." The difficulty of specifying a chronology for Goya's work solely on the basis of stylistic analysis is well recognized. Nevertheless, for technical reasons, we may place a series of small paintings among the first works painted by Goya after illness had affected his imagination. Almost identical in format and size, they are devoted to representations of catastrophes: *The Shipwreck* (figure 25), *Bandits Attacking a Coach*, and *The Fire* (page 67).

Stylistically related to *The Fire* is a small panel depicting *Comedians at a Fair*, and a series dedicated to the outrages of brigands (figure 26), now in various Madrid collections. The luminous contrasts of these minutely executed works tend to dissolve all linearism; thus they already correspond to the full-blown Goyesque manner. In effect, these paintings not only renounce line completely, but also remove the focus on depth, substituting an ambience detailed by flashes of light and shade enveloped in mist. Goya manages luminous spots and reflected lights with such intuition that impressions of volume, distance, light, and movement remain in perfect harmony with the emotion and feeling of the subject. Much more is suggested than actually appears. At certain points, very notable plastic values successfully achieve with relatively dense modeling an almost academic shaping of form.

Judged by their technical simplifications, four paintings of the same type that are part of another series are

somewhat later. The titles by which they are known are: *The Devil's Lamp* (National Gallery, London), *Witches in Flight* (Ministry of the Government, Madrid), and two scenes of *The Witches' Sabbath* (page 69). Goya here expresses the imminence of his visions and the spectral ambience. Despite simplifications of form, he maintains an extreme realism, made more pointed by the contrasts offered by specific deformations and very terrifying faces. It is recorded that the Duke of Osuna paid Goya for these paintings in 1798, but they were certainly painted some years earlier. We believe that the small self-portrait formerly in the Pidal Collection, Madrid, reveals with impressive truthfulness the debilitated face of Goya during these

27. TWO POETS (detail from THE ALLEGORY OF POETRY). *c.* 1797. Oil on canvas. *National Museum, Stockholm*

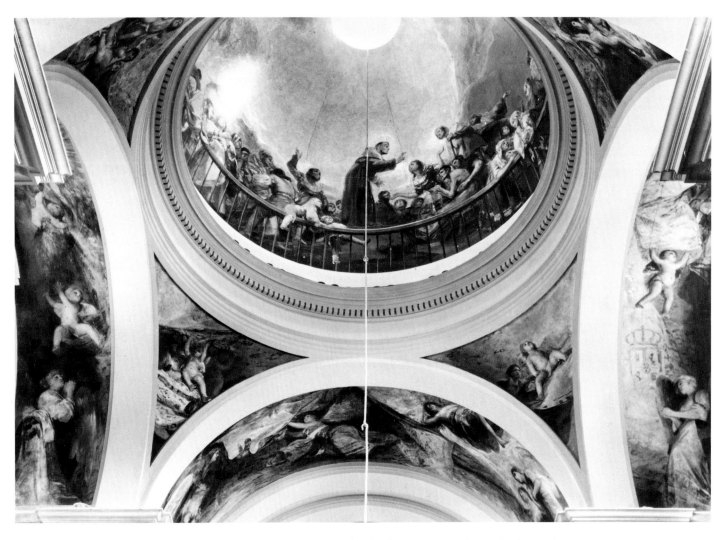

28. WALL PAINTINGS. 1798. Fresco. *Church of San Antonio de la Florida, Madrid*

months of despondent dreaming. Goya later gave the portrait to the Duchess of Alba, who still had it in her possession at her death in 1802.

The works of the affected imagination, executed in the long hours of loneliness, were followed by Goya's return to the public life of the court. By July, 1793, he was again attending meetings of the Academy. The only portrait dated in this year is that of *Caveda*. Of the following year, 1794, are the portraits of the actress *"La Tirana"* (Collection March, Palma de Mallorca, and Academy of San Fernando, Madrid), and *Ramón Posada y Soto* (M. H. de Young Memorial Museum, San Francisco, Kress Collection). Portraits, probably also of this year, are *Pérez Estala* (Kunsthalle, Hamburg), *General Ricardos* and *Tadea Arias* (Prado Museum, Madrid), and that of *Judge Altamirano* (Museum of Fine Arts, Montreal)—all executed with

complete control of a new technique. The impressionism obtained with misty blues, which appeared in portraits preceding Goya's illness, was partially renounced in order to reinvestigate the linear element used in specifying the features psychologically. This factor is augmented by the tactile value of certain elements, thus establishing a variety of qualities with an equilibrium that is always surprising when analyzed, though it is absolutely logical on contemplating the image from the aesthetic viewpoint. It is a technique of rapid brush strokes, with a very fluid medium that glides on a hard, brilliant preparation perfectly covering the grain of the canvas. Black is generously used, though without close mixing with any color; it results in a grayed tonality in the total conception.

Francisco Bayeu, with whom Goya had made his peace—as is shown by the extraordinary "gray" por-

trait of him (Prado Museum)—died in 1795. Goya succeeded him as director of the Academy's Division of Painting. Physically recuperated, Goya now begins one of the most brilliant periods of his career. It was probably at this time that his relationship with the Duke and Duchess of Alba began, and with it emerges one of the most debated topics in the story of Goya. It is evident that when he entered the intimate circle of this great ducal house, Goya was not the provincial genius who had portrayed the family of the Infante Don Luis. Nor was he the self-conscious and proud painter whose works were admitted with discreet cordiality into the house of the Osunas. He was, in fact, a man who had suffered and who was without any consolation other than his art. He would be welcomed with admiration and affection by the Duchess

29. SELF-PORTRAIT. 1800.
Oil on canvas, 24³/₄ × 19¹/₄". *Goya Museum, Castres*

Cayetana (Alba), then the central figure of Spanish aristocracy, who was envied by the queen herself and admired by all for her beauty and her personality. Goya's paintings that relate to the duchess are a full-length portrait of the duke (Prado Museum, Madrid) and one of the duchess (Liria Palace, Madrid), both of 1795; and small, humorous scenes with the duchess, her elderly duenna, and the two children who lived under her protection, María de la Luz and Luis de Berganza. The scenes show Goya's affectionate relationship with the house of Alba.

In August of the same year, a letter to Zapater mentioned, with ironic coarseness, a visit paid by the duchess to the painter's studio. In 1797, Goya stayed in Sanlúcar, where the duchess lived following her husband's death in June, 1796. At Sanlúcar, Goya made many drawings of the widow in his sketchbooks, and it was there that he painted the famous portrait in which she appears dressed in mourning (page 71). In this portrait, the duchess wears two rings, one with the name of Alba and the other with that of Goya; moreover, in the lower part, there may now be read, like writing in the sand, the inscription, "*Solo Goya*" ("Goya only"), uncovered recently after X-ray examination though previously covered with old repainting. Slightly later—at an unspecified date—Goya composed on one of the unused plates of his *Caprices* series a complete composition evidently alluding to the real or imagined duplicity of the duchess. This meaning is made clear in the inscription, "*Sueño de la mentira y inconstancia*" ("Dreams of falsehood and inconstancy").

Having examined all of this evidence, and given the physical condition and character of the protagonists, it is difficult to accept the existence of a love shared by both. That the cited portrait of the widowed duchess did not leave Goya's hand must be taken into account; he had it in his house in the inventory of 1812 and left it to his son. Therefore, the compromising names on the rings and the obliterated postscript, "*Solo Goya*," could have been added later, without the knowledge of the duchess. The etching deleted from the final edition of *The Caprices* corroborates the existence of a strong feeling on the part of the artist, a feeling not reciprocated by the duchess. In any event, after the

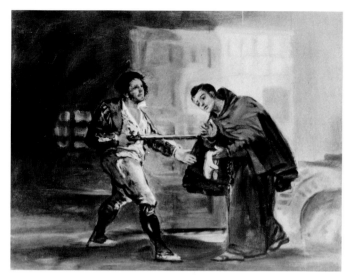
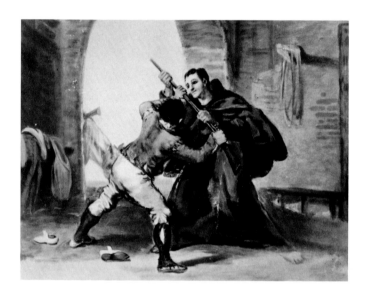
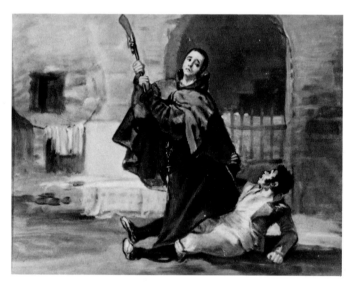
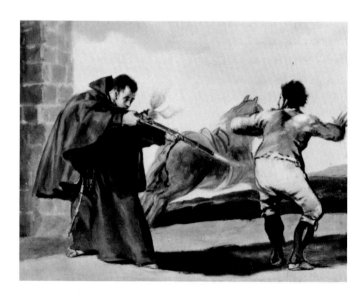
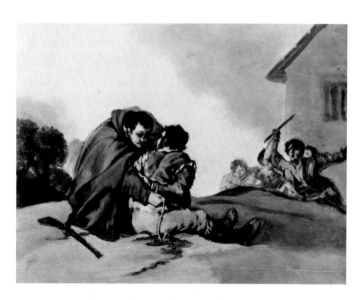

30. CAPTURE OF THE BANDIT MARAGATO BY FRAY PEDRO DE ZALDIVIA (six panels). 1806–7.
Oil on wood, each panel 12¹/₄ × 15″. *The Art Institute of Chicago*

duchess' death in 1802, Goya began—though he did not complete—a project of paintings for the decoration of her tomb.

Modern critics do not accept the identification of four small panels at the Academy of San Fernando—*The Procession of the Flagellants*, *Bullfight*, *Inquisition Tribunal*, and *The Madhouse* (figure 31)—as representing those alluded to in the cited letter to Iriarte. In effect, the technique of these four justly celebrated compositions is later than that of the groups of grossly imaginative paintings described in the preceding paragraphs. Formal precision has been radically replaced by an impressionism of vigorous daubs executed with a very fluid medium. A black tonality has completely invaded the entire terrain, altering its hues by its insistent juxtaposition. The technique coincides positively with that of the often-reproduced *Burial of the Sardine* (Academy of San Fernando, Madrid), and indicates a direction that would be seen in the future, not only in the so-called black paintings of the Quinta del Sordo, but also in the majority of compositions and portraits of relatively free execution. This is a quality that imposes character on Goya's works; further, it is a factor that must always be considered in suggesting, by means of stylistic analysis, a chronology for Goya's undated paintings. Works that are technically closest to the four small Academy panels are Goya's sketches (Lázaro Museum, Madrid) for some altar paintings, which, in 1801, Jovellanos saw in the Saragossa Church of San Fernando en Monte Torrero. Therefore, this date—1801—is proposed as the latest possible for the execution of these paintings that constitute one of the most interesting groups in the stylistic evolution of Goya.

Several portraits are dated in 1797: *Bernardo de Iriarte* (Museum of Fine Arts, Strasbourg), *Juan Meléndez Valdés* (Spanish Bank of Credit, Madrid), *Martín Zapater*, etc. They confirm the persistence of a technique that successfully achieves its maximum potential in two undertakings that break the monotony of studio works: the decoration of Godoy's palace and the frescoes of the Madrid Church of San Antonio de la Florida. As for the palace decorations, the elements of which they were comprised are not specifically known. The large medallions executed in 1797 for the *perron*,

or outer entry, remained in place until fairly recently; they represented allegories of Commerce, Industry, and Agriculture (Prado Museum, Madrid). The two large compositions, *Spain*, *Time*, *and History* and the *Allegory of Poetry* (detail, figure 27), also belonged to the decorations. These exceptional works, though obscured by successive repaintings suffered during their lengthy and unfortunate travels, have regained their pristine quality in recent cleaning (page 73). Also from Godoy's collection are the two famous *majas*, *The Maja Clothed* and *The Maja Nude* (pages 79 and 81), which are clearly of the period now under study.

The year 1798 is one of the most productive of Goya's career. Even judged from only what is known with absolute certainty, Goya's capacity for work is almost unbelievable. In addition to a normal number of portraits—including *Jovellanos* (Collection Duke of Las Torres, Madrid), *Camarón* (Collection Contini-Bonacossi, Florence), *Ferdinand Guillemardet* (The Louvre, Paris), and *Doctor Peral* (page 75), etc.—Goya painted *The Taking of Christ* in the sacristy of the Cathedral of Toledo, and the frescoes of the Church of San Antonio de la Florida (figure 28 and page 77). The proven fact that in its entirety this latter decoration was painted by Goya's own hand between August and November fully justifies what has been said concerning the extraordinary faculties of the artist.

Apparently, the monarchs finally realized Goya's worth; they granted him the longed-for title, First Court Painter. In 1799, the superb portraits of *Charles IV* and his queen, *María Luisa* (Royal Palace and Prado Museum, Madrid), were rendered. A good number of additional portraits were also executed, among them *The Marquis of Bondad Real* (The Hispanic Society of America, New York), *The Marquise of La Merced* (The Louvre, Paris), *Leandro de Moratín* (Academy of San Fernando, Madrid), *The Marquis of Villafranca* (Prado Museum, Madrid), *General Urrutia* (Prado Museum, Madrid), and others.

Goya's most important painting of 1800 was the large *Family of Charles IV*. In this family portrait, the royal figures seem fashioned without concessions of any kind (pages 83 and 85). As was Goya's usual procedure for commissioned portraits developed in

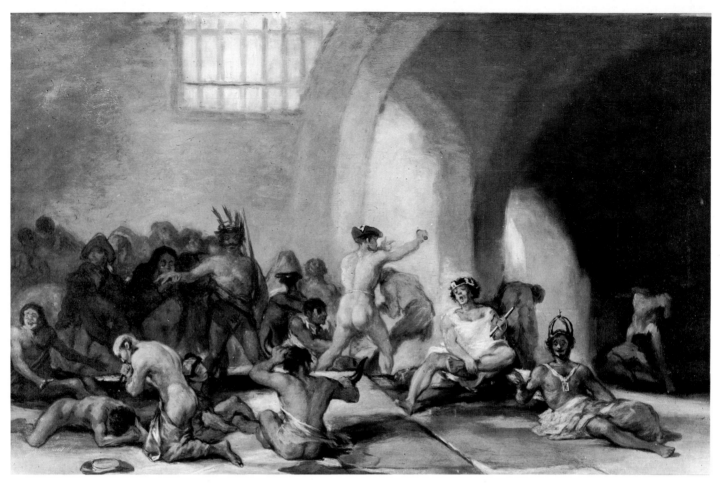

31. THE MADHOUSE. C. 1800. Oil on wood panel, 17¾ × 28⅜". *Academy of San Fernando, Madrid*

the sitter's absence, admirable and lively studies from the model were painted first, in very rapid studio sessions, for each of the figures in the final group portrait. Following the example of Velázquez, who portrayed himself in *The Maids of Honor*, Goya included himself in the background shadows behind the royal family. Although this self-portrait is simply a head executed with very light strokes, Goya in addition painted a conscientious study, the exceptional *Self-Portrait* at the Castres Museum (figure 29). In the so-often modified chronology of Goya's work, this self-portrait remains definitely fixed in date. Also of this year is the portrait of Godoy's wife, *The Countess of Chinchón* (page 87).

A period of tranquillity and well-being then began in Goya's life, lasting until the war of 1808 again confronted him with pain and tragedy. In 1801, Goya portrayed Godoy, the monarchs' favorite administrator, in a full composition that richly surrounded the sitter with narrative and realistic details referring to the war with Portugal (Academy of San Fernando, Madrid). The lighting is very correct and natural, and the sky shows great richness of tints within limited contrasts of tone. Of the same date are the portraits *Antonio Noriega* (The National Gallery of Art, Washington, D.C., Kress Collection), *The Architect Isidro González Velázquez*, *The Marquise of Lazán* (Collection Duke of Alba, Madrid), etc. Of 1803 are the portraits of *The Count of Fernán Núñez* (page 89) and of his wife; indicated in both is an unusual interest in clarity of contours and strength of line.

The 1805 portrait *Félix de Azara* (Provincial Museum of Fine Arts, Saragossa) displays a certain density of impasto and a clarity in the representation of details. Also of this year is *The Marquise of Santa Cruz*, of which Goya painted two versions, both presenting the attributes of Euterpe (Collection Valdés, Bilbao, and County Museum, Los Angeles), and the extraordinary *Isabel Cobos de Pórcel*. In the latter, intensified plastic qualities serve a model of exceptional personality; the splendid harmony between the green of the background and the golden ocher tone, which dominates in the figure, is particularly outstanding. The figure itself is vividly drawn, and exhibits resplendent flesh tones (National Gallery, London). The dominant interest Goya always gave to the human

elements is most thoroughly accomplished in the portrait genre. Among the most successful of the year now under study, 1805, is that of Goya's son, Javier. In this portrait of his fine and elegant son, Goya disclosed all the desires of his spirit, both as a painter and as a father. The portrait was executed on the occasion of the marriage of the great painter's only heir; it has a worthy mate in the admirable *Portrait of Gumersinda Goicoechea*, Javier's young wife (Collection Noailles, Paris). On this occasion, Goya also portrayed other members of the bride's family, in small oils on copper (Collection Salas, Madrid, and Rhode Island School of Design, Museum of Art, Providence). Other portraits of the same year are *Leonor Valdés de Barruso* and *Vicenta Barruso de Valdés* (Collection O'Rossen, Paris), *Tadeo Bravo del Ribero* and *José de Vargas Ponce* (Academy of History, Madrid), and, perhaps, *The Marquises of Castrofuerte* (Museum of Fine Arts, Montreal), extraordinary for its synthesizing quality.

The series of six paintings in cinema-like sequence dedicated to the capture by Fray Pedro de Zaldivia of the bandit Maragato corresponds to the years 1806–07 (figure 30). In this series, there is a change with respect to earlier series. The scene is constructed from a very close viewpoint, the figures thus acquiring monumentality; details are unqualifiedly simplified. Also painted were the portraits of *Isidoro Maiquez* (Prado Museum, Madrid), *Pedro Mocarte, The Marquis Caballero* (Museum of Fine Arts, Budapest), *The Count of Teba* (Frick Collection, New York), *Sabasa Garcia* (page 111), and others.

1808–28

For ten years Goya had enjoyed an evenly balanced life. He had achieved precisely what he always had sought, since his infancy and early youth. He was Spain's first painter, and, in spite of his deafness, he maintained a constant relationship with rulers and the nobility. He was rich, though he lived modestly; worries concerning the phantom of poverty lay dormant under the warmth provided by savings well invested. He was called *Don Paco el Sordo* (Frank, the Deaf Man), and people admired him; painters unconsciously broadened his stylistic orbit. But the deliberately paced evolution of the Goyesque genius

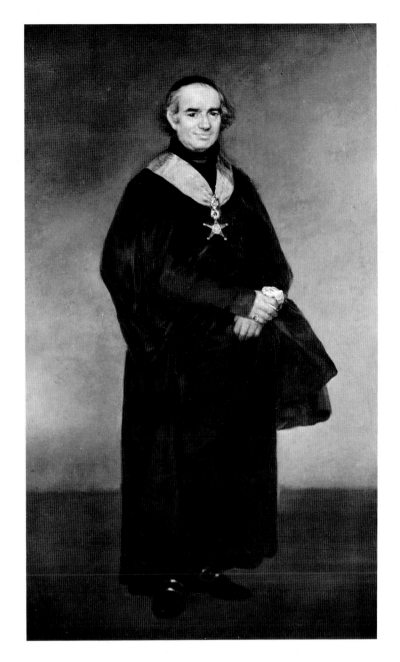

32. PORTRAIT OF JUAN ANTONIO LLORENTE. *c.* 1811. Oil on canvas, 74³/₄ × 45″. *Museu de Arte, São Paulo, Brazil*

was altered in 1808 by the Napoleonic occupation of Spain. The life of the nation was transformed with tempestuous agitation and a rapid succession of tragic events. On March 18, insurrection at Aranjuez caused the abdication of Charles IV, imprisonment of Godoy, and the proclamation of Ferdinand VII as king. Four days later, Murat peacefully entered Madrid at the head of the French army. Goya was commissioned by the Academy to paint an equestrian portrait of the

new monarch (Academy of San Fernando, Madrid); it was executed in two rapid sessions on April 6 and 7, three days before Ferdinand left for Bayonne, not to return until after the occupation.

The people of Madrid were not slow in reacting against the Napoleonic intrusion. On the second of May, right in Madrid's central Puerta del Sol, a detachment of mamelukes was attacked. The consequent brutal repression, with multiple shootings on the night of May 3, inflamed the guerrillas, who stained Spain with blood for more than four years. However, Madrid recovered an apparent normality; many Spaniards in the city accepted hopefully the arrival of the French spirit of reform. It seems that Goya, though censorious of the abuses and cruelties of the occupation army, did not react as the majority did against all that represented French influence. He was certainly a friend of the so-called *afrancesados* ("Spanish sympathizers of the French"), who cooperated and assumed direct control during the ephemeral reign of Napoleon's brother, Joseph I. Between October and December of 1808, however, Goya was in Saragossa, painting and sketching scenes of the battle led by General Palafox against the invaders. These paintings were shortly thereafter destroyed by French bayonets of the same expedition. On returning to Madrid, Goya continued to paint portraits, among them two dated 1809, *General José Queralto* (Collection Haberstock, Berlin) and *Minister José Manuel Romero* (Nelson Gallery–Atkins Museum, Kansas City, Mo.). In 1810, he painted the portraits of *General Nicolás Guye* and his nephew *Victor* (National Gallery of Art, Washington, D.C.). Goya continued as court painter, rendering an allegorical composition with the portrait

33. SOLDIERS SHOOTING AT A GROUP OF FUGITIVES. *c.* 1809–12. Oil on canvas, 12⅝ × 22¾". *Collection Marquis of La Romana, Madrid*

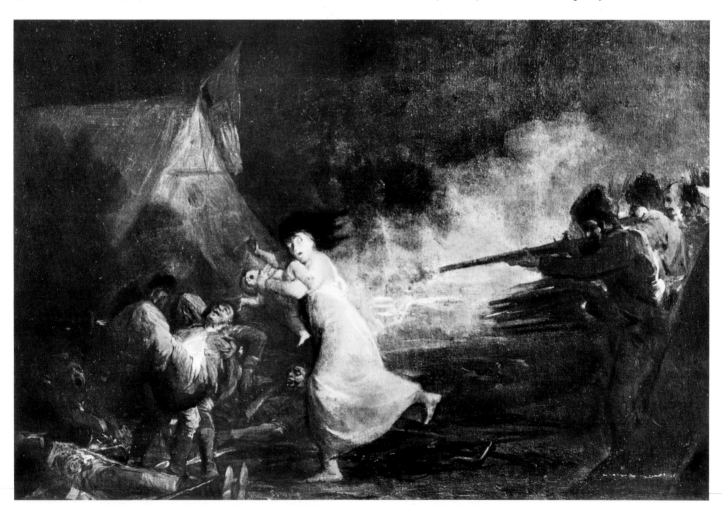

of the intrusive King. This *Allegory of the City of Madrid* (page 91) has had various titles, and is also known popularly as *"The Second of May."* Full of color subtleties, this allegory maintains a very close relationship with the previously mentioned *Spain, Time, and History*. Portraits followed, including the masterful rendering of the actress *Antonia Zárate* (Collection Beit, London), of 1811. One of the most extraordinary of nineteenth-century portraits, that of the ecclesiastic *Juan Antonio Llorente* (figure 32 and page 93), is probably also of 1811.

Since the war continued to exhaust the nation, Goya had few commissions in 1812. Certainly it was for this reason that he decided to paint the large *Assumption of the Virgin* for the parish church of Chinchón, governed by his brother, Camilo. It is a very original work, well apart from tradition in Spanish religious painting. However, it is perfectly logical, if it is regarded as a highpoint in Goya's stylistic development, beginning with the Fuendetodos reliquary and closing with the cupola paintings for the church of San Antonio de Florida. During this period, Goya was already working on a series of prints not finished until some time later, *The Disasters of War* (see figures 49–50). But work sufficient to accord with the feverish activity of a man like Goya is still lacking for this period. Therefore, it does not seem unreasonable to attribute to these years of social unrest some of the works mentioned, together with the paintings of war, in the testament of Goya's wife, whose death occurred on June 20, 1812. The inventory of her possessions, published and cleverly commented on by Sánchez Cantón, provides a record of considerable interest for learning about Goya's mode of living.

In addition to descriptions of furniture and clothing, mention of a large number of jewels reveals an instinct for investment in secure items. The inventory also contains a valuable account of paintings owned; among these appear works by Velázquez, Tiepolo, and Correggio, in addition to seventy-three by Goya's own hand. The portrait of the Duchess of Alba in widow's garb—noted in the preceding section—is included. Other paintings mentioned are: the portrait of the bullfighter *Pedro Romero;* the series concerning the bandit Maragato, already noted; two canvases

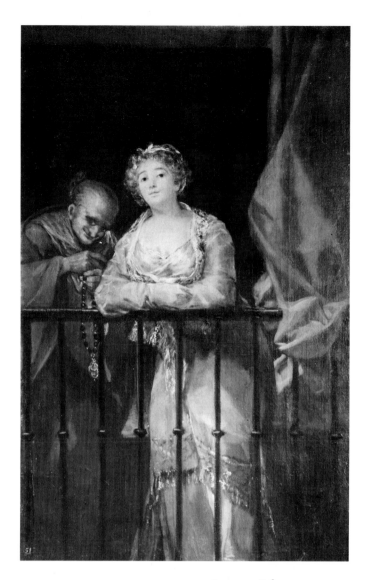

34. THE MAJA AND CELESTINA. *c.* 1809–12. Oil on canvas. $65^{1}/_{8} \times 42^{1}/_{2}''$. *Collection March, Palma de Mallorca*

of *The Majas on a Balcony; Two Drinkers; The Water Seller* (page 97); and *A Knife Grinder* (page 95). The last three must be those now in the Budapest Museum.

There were also listed: *The Weavers,* published by Mayer; twelve *bodegones* ("still lifes"); twelve pictures with the subject *Horrors of War;* and *The Colossus.* The relatively high evaluation assigned in the inventory to the twelve war scenes makes it unlikely that these were the small Goyas of the same subject now extant. On the other hand, one of them could be the impressive canvas in which a group of soldiers fires on an encampment (figure 33). The last work cited in the inventory could be the Prado's canvas presenting the disordered flight of a multitude before a gigantic figure looming in the distance (page 99). Its evident allusion to war

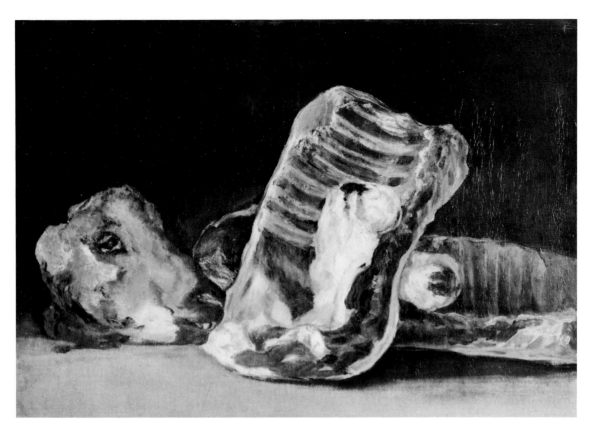

35. STILL LIFE WITH THE HEAD OF A LAMB. Before 1812. Oil on canvas, 17¾ × 24⅜".
The Louvre, Paris

dates this work, and it is interesting, since it unites in technique with several paintings of bullfights and with other pictures, such as *A City on a Rock* (page 101) and *The Balloon* (Municipal Museum, Agen). In these very freely executed paintings, savage superimpositions of dense impasto appear, applied and modeled with the spatula or with the double-pointed reed that was mentioned in statements by Goya's son some years after the artist's death.

The *Majas on a Balcony* (page 103) and *The Maja and Celestina* (figure 34) could be the two "Young women on a balcony" cited in the inventory. Their technique does not differ from that of works dated between 1808 and 1812, and even the themes complement each other. The first canvas represents two *majas* in full light on a balcony; a supporting role is played by two men placed in the background shadow. The second scene presents the elderly Celestina remaining in the shade, her young woman exploited to full advantage by the light falling on the balcony. Both canvases, landmarks in Goya's art, could hardly have been commissioned works. It seems to have been precisely during periods of loss of contact with his usual clientele that Goya created, for himself, his best works. For identical reasons, the writer considers as of this period the Lille Museum's notable pair of canvases, *The Love Letter* (page 105) and *"Qué tal?"* *("How Goes It?")*; both recall certain of *The Caprices* plates (see figures 47–48) in subject matter and spatial conception. It is always difficult, even for those accustomed to aesthetic analysis, to place Goya's extant compositions in precise chronological order when they lack both history and date.

The twelve *bodegones* mentioned in the 1812 inventory may reasonably be identified with those found in various museums and private collections, some signed and others not. These still lifes are painted with sobriety, and even their subject matter is solemn and at times surprising. One example is that from the Louvre (figure 35).

With Madrid freed by Wellington's troops in August, 1812, Goya painted the equestrian portrait of the English general. A faint greenish hue gives this canvas the phosphorescent glow that characterizes paintings of Goya's final period. As may be expected, military subject matter filled these years, as in sketches

such as *The Manufacture of Gunpowder and Cannon Balls in the Tardienta Mountains* (figure 36). Commissioned by the regency established in January of 1814, Goya painted two large canvases, the battle scene *The Second of May, 1808, at Madrid* and *The Third of May, 1808, at Madrid: The Shootings on Principe Pío Mountain* (pages 107 and 109); an extant preparatory sketch for the former canvas was painted with true freedom (figure 37). Many official portraits of Ferdinand VII, generals, and war heroes followed, including *General Palafox* (Prado Museum, Madrid) and *"El Empecinado," Don Juan Martín* (Collection Neugebauer, Venezuela).

Portraits dated in the following year indicate a return to normal existence. As always, those painted rapidly in front of the model—according to Goya's son, in a single day—alternate with full-length portraits destined for palace salons or Council rooms, where they would perpetuate the memory of political-

ly or socially prominent persons. Among the first group must be mentioned two superb self-portraits (Prado Museum and the Academy of San Fernando, Madrid); a portrait, *Ignacio Omulryan* (figure 38), of impressive strength and severity; also *The Engraver, Esteve* (Museum of Fine Arts, Valencia); *José Munarriz* (Academy of San Fernando, Madrid); *Fray Miguel Fernández* (Art Museum, Worcester); and the admirable *Portrait of a Woman Dressed in Gray* (page 113), modeled with a very fine range of roses and yellows traversed with black rhythms. Typical examples of the official portraits are *The Infante Don Sebastian Gabriel de Borbón (page 115)*, *The Duke of San Carlos*, and *Don Miguel de Lardizabal*, dated 1815 (page 119).

The nobility again supported Goya's studio. In 1816, he painted an ingenious portrait, *The Duchess of Abrantes* (Collection Marquis del Valle de Orizaba, Madrid), and one of great firmness, *The Duke of*

36. THE MANUFACTURE OF GUNPOWDER AND CANNON BALLS IN THE TARDIENTA MOUNTAINS (detail).
c. 1813. Oil on wood panel. *Casita of the Prince, El Escorial*

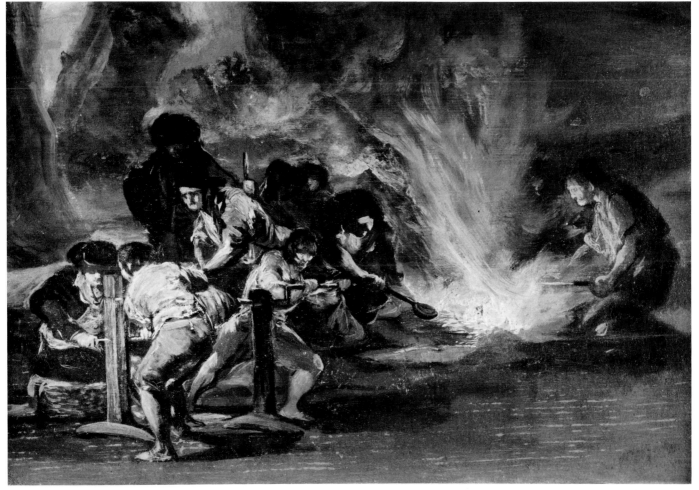

Osuna (Bonnat Museum, Bayonne); a preparatory drawing and sketch for the latter are extant (Kunsthalle, Bremen). The sober portrait *Countess of Gondomar* (Institute of Arts, Detroit) would be contemporary. An enormous canvas, *A Meeting of the Company of the Philippines* (detail, figure 39), also corresponds to this period. In the opinion of the writer, the extraordinary value of this painting has not received the attention it merits; its somber tones are executed with a vigor incredible in a man of seventy, a man who had lived for twenty-four years in the enforced isolation that followed his loss of hearing. But he is now at the threshold of his most characteristic and most widely popularized artistic period. Either during or just following this year, Goya completed the etched series, *Disasters of War* (see figures 49–50) and *Disparates*

(The Proverbs). The latter, in a certain respect, is a development of the theme of *The Caprices* (see figures 47–48), which places it in a fantastic world soon to serve as the basis for the Quinta del Sordo paintings.

The documented grisaille of 1817, *Saint Isabel Caring for the Ill* (figure 40), was the last of the works executed for the Royal Palace at Madrid. Its tortured technique contrasts very clearly with the diaphanous simplicity of the *Saints Justa and Rufina*, painted for the Seville Cathedral during the same year. A single dated portrait of 1817, *The Painter Arango*, does not in any sense disturb Goya's pictorial conception. His manner of portraiture passes without explicable continuity to the blunt technique of *The Architect Antonio Cuervo* (The Cleveland Museum of Art), dated in 1819. How might we fill the intervening year? The extraordinary

37. THE SECOND OF MAY (detail of sketch). 1814. Oil on paper pasted on panel. *Collection Duke of Villahermosa, Madrid*

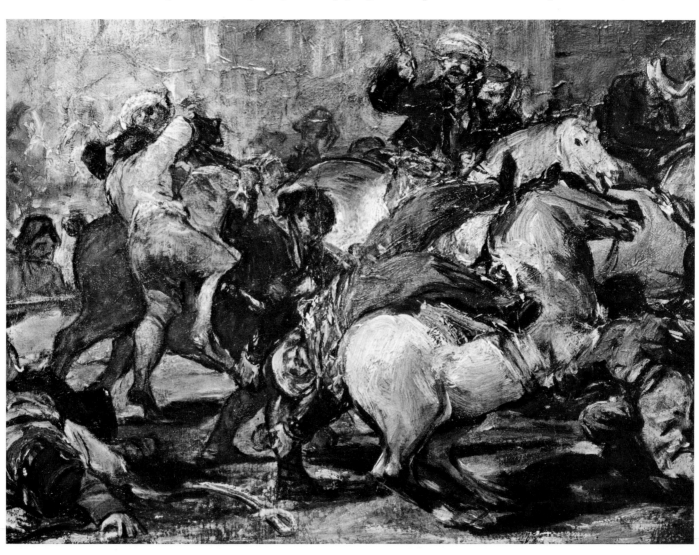

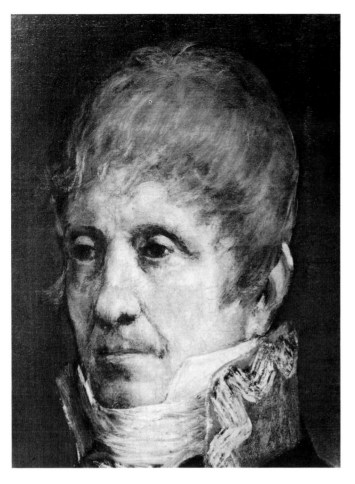

38. PORTRAIT OF IGNACIO OMULRYAN (detail). 1815. Oil on canvas. *Nelson Gallery–Atkins Museum, Kansas City, Missouri*

out the intervention of the usual pictorial instruments (figure 42 and page 117). The second is a small version, perhaps a preparatory study for the first, painted almost completely in the elastic and imperfectly ground daubed blacks that characterize the works of Goya's last years.

The date 1819 inscribed on the *Garden of Olives* and on *The Last Communion of San José de Calasanz* in the Church of San Antonio Abad, Madrid—the latter (page 121) painted between the months of May and August—simply confirms what has been said regarding Goya's technique during this period. The list of works similarly constructed might be extended by the inclusion of *The Exorcized* (Prado Museum, Madrid), and two canvases, both entitled *The Bullfight* (The Metropolitan Museum of Art, New York, figure 43, and Museum of Art, Toledo), and some others. All of the above indicate years of relative activity, but

Procession (detail, figure 41) may logically be of 1818. It is painted almost exclusively with Goya's singular spatula work, which here attains surprising qualities, based upon superimpositions and arbitrary blendings of black, white, and ocher. Other pictures of similar structure, unfortunately not well known, seem to form a series with the *Procession*. We are thus at the borders of the abstract world of quality attained by texture, to which Goya, though not entering, nevertheless opened a door. He finally arrived at the truth discovered by Titian in his old age and by Velázquez in his youth, that color is of little import; rather, what is essential in painting is tone, and above all, the balance of values.

In the same technique, and consequently of the same period, are two paintings titled *The Forge* (Frick Collection, New York, and Collection Elosúa, Bilbao). In the first, Goya constructs three life-sized, tortured figures, with blobs of black and white which at times seem designed to render the figures accidentally, with-

39. A MEETING OF THE COMPANY OF THE PHILIPPINES (detail) *c.* 1816. *Goya Museum, Castres*

40. SAINT ISABEL CARING FOR THE ILL. 1817.
Oil on canvas, 66¹/₂ × 50³/₄". *Royal Palace, Madrid*

also they indicate a tendency toward creating a greater intimacy, as if to suggest that Goya was breaking away from the world and his clientele of church and court. His acquisition in February, 1819, of the house in Madrid's countryside, the famous Quinta del Sordo— now destroyed—seems to confirm the painter's wishes for isolation. On April 4, he attended sessions of the Academy for the last time. From the dedication on *The Self-Portrait with Doctor Arrieta*, it is known that Goya suffered another grave illness at this time. During the painful hours of his convalescence he probably conceived the idea of the fantastic decoration of the country house, the *pinturas negras* ("black paintings"), which had entered the Prado Museum by 1882 (page 125).

In the preceding pages, repeated references have been made to Goya's preparatory sketches, which, however, have never been conceded the importance they merit, both by virtue of their grand plastic values and as a document indispensable to the proper study of the aesthetic development of this great painter. They are preserved in sufficient numbers to permit us to affirm that Goya never executed a composition or portrait without first painting a preparatory sketch. The impressive sketch recently acquired by the Basel Museum (figure 46)—a sketch for one of the Quinta del Sordo paintings—proves that even Goya's most intimate works were preceded by a study or approximation of the final oil painting. For Goya, the process of realization of a work began with a rough sketch or preparatory drawing that served to block out the theme and place it in the space. There then followed the oil sketch, on which he occasionally worked at length, resolving problems of light, color, perspective, and composition. Next, he was accustomed to make drawings from nature, with a more academic criterion, in order to analyze details of the work. In general, there is a notably close relationship between the sketch and the final work. The foregoing leads one to believe that Goya understood the value of his sketches, and further, that he gave them a very particular importance. The artist's own observations support this idea. In 1801, he wrote in a memorandum concerning restoration: "It is not easy to retain the instantaneous and transitory design that issues from the imagination, and the accord and agreement put into the first execution, so that final retouchings give way to variations." By this Goya meant that, in his opinion, the painting, in translating the outlines and colors of the sketch to final form, lost its spontaneity and deepest emotion. Goya's own works substantiate his thesis, since the strength and beauty of his sketches equal, when they do not surpass, the interest of his finished works. This is comprehensible in the work of a painter whose genius is characterized precisely by spontaneity, boldness, and inventiveness of execution.

To judge by technique and subject matter, a series of cruel and enigmatic small paintings, reflecting the manner of the Quinta del Sordo oils, was probably begun in 1819, during Goya's period of retreat. *A Duel, Carnival Scene, Preaching Monk* (page 123), *Punishment of a Sorceress, Seated Man,* and others, are filled with a threatening atmosphere which creates an impressive psychological tension. Their sublime execution unites them with the potent *Repentent Peter* (The Phillips Collection, Washington, D.C.) and *Saint Paul,* Goya's last religious paintings.

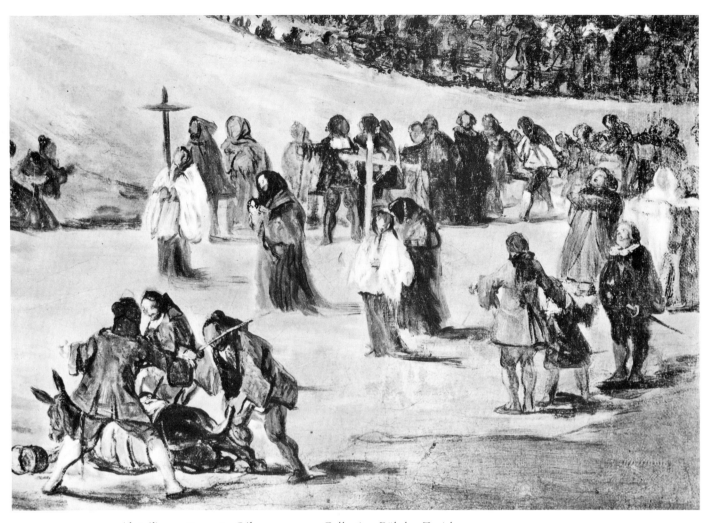

41. THE PROCESSION (detail). *c.* 1817–18. Oil on canvas. *Collection Bührle, Zurich*

42. THE FORGE (detail). *c.* 1815. Oil on canvas. *The Frick Collection, New York (see colorplate)*

41

The country house was ceded to Goya's grandson, Mariano, in September, 1823. Goya, who had shown himself a partisan of the liberal constitution, feared attachment of his property as a consequence of political retaliation; Ferdinand VII, supported by the French army of the "Hundred-thousand sons of St. Louis," under the command of the Duke of Angoulême, imposed absolute monarchy. For three months Goya took refuge in the house of the priest Don José de Duaso y Latre, censor, and editor of the periodical *La Gaceta*. There Goya painted the portraits of his protector (Collection Rodríguez Otín, Madrid) and of the priest's nephew, *Ramón Satué*, a justice of the court (Rijksmuseum, Amsterdam). Still, Ferdinand VII and his counselors did not sympathize with Goya; the artist, old and pained, found things going badly in the closed atmosphere of Madrid. He officially asked for, and obtained, permission to take the cure of the waters at Plombières, France, in May of 1824. Goya first went to visit Moratín, who had sought refuge in Bordeaux. Moratín wrote the following in one of his letters: "Goya has come, deaf, old, torpid, and weak . . . but very content and anxious to see the world." The painter then visited Paris, remaining there until September. While in Paris, he painted a portrait of Joaquin María Ferrer and his wife.

Goya was installed at Bordeaux in October, living with Doña Leocadia Zorrilla and her children, Guillermo and Rosario Weiss. He again painted portraits, extraordinary for their simplicity, including *Moratín* (Museum of Paintings, Bilbao) and *María Martínez de Puga* (The Frick Collection, New York).

Goya requested an extension of the permission for absence from the court and this was granted to him in

43. THE BULLFIGHT (detail). *c.* 1819. Oil on canvas. *The Metropolitan Museum of Art, New York*

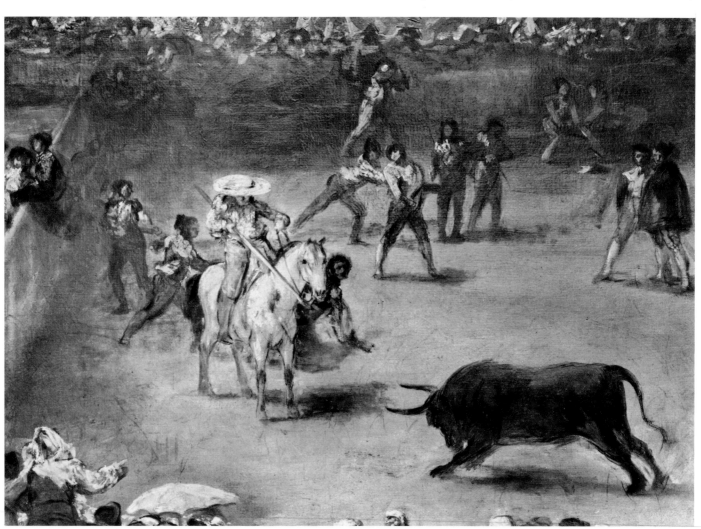

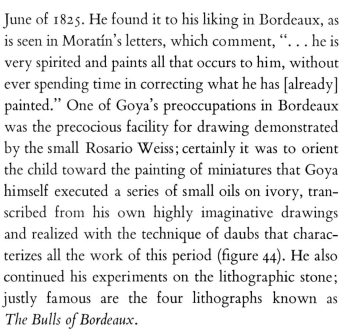

LEFT: 44. TWO HEADS. *c.* 1825. Miniature, oil on ivory. *Rhode Island School of Design Museum of Art, Providence*

BELOW: 45. THE DRUNKEN MASON. 1791. Oil on canvas, $13^3/_4 \times 5^7/_8$". *The Prado Museum, Madrid*

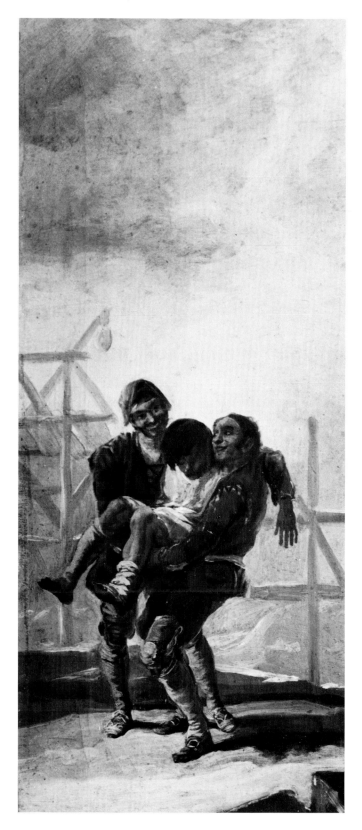

June of 1825. He found it to his liking in Bordeaux, as is seen in Moratín's letters, which comment, ". . . he is very spirited and paints all that occurs to him, without ever spending time in correcting what he has [already] painted." One of Goya's preoccupations in Bordeaux was the precocious facility for drawing demonstrated by the small Rosario Weiss; certainly it was to orient the child toward the painting of miniatures that Goya himself executed a series of small oils on ivory, transcribed from his own highly imaginative drawings and realized with the technique of daubs that characterizes all the work of this period (figure 44). He also continued his experiments on the lithographic stone; justly famous are the four lithographs known as *The Bulls of Bordeaux.*

Goya returned to Madrid in May of 1826 and was apparently well received—even by the king, who ordered Vicente López to paint Goya's portrait (Prado Museum, Madrid). In every possible way, Goya sought to obtain his retirement pension; on its being granted, he returned to Bordeaux in July, accompanied by his grandson Mariano. Of the following year, 1827, are the painter's last works of true force. Some of the excellent paintings that are known include the effigies of a religious brother and a nun, *The Portrait of Juan Muguiro* (Prado Museum, Madrid), and the portrait,

46. FANTASTIC VISION (sketch for a composition for the Quinta del Sordo). *c.* 1820. Oil on canvas. *Museum, Basel*

Mariano Goya. But the masterpiece of this final moment is the magnificent *Milkmaid of Bordeaux* (page 127). Here a new and final change in Goya's manner may be appreciated, accomplished with a more lyrical and delicate palette in union with proper moderation of the impasto. Left unfinished in 1828 is the sober and intensely worked *Portrait of José Pio de Molina.* On April 16 of that year, the great painter died outside his native country. His mortal remains were brought to Spain in 1901, at the beginning of the century that would develop to a most unusual extreme many of the bold techniques that had appeared in his work.

PRINTS

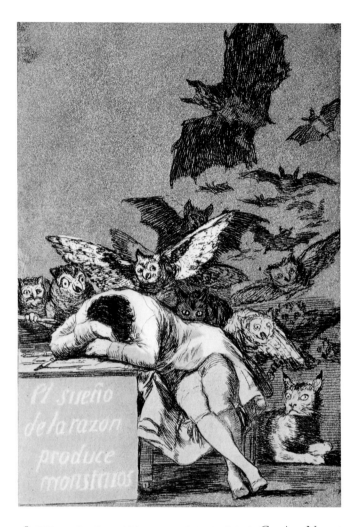

48. THE DREAM OF REASON PRODUCES MONSTERS. *Caprices*, No. 43.
1793–96. 7³⁄₁₆ × 4¾"

47. WHAT WILL HE DIE OF? *Caprices*, No. 40.
1793–96. 7⁵⁄₁₆ × 5⅜"

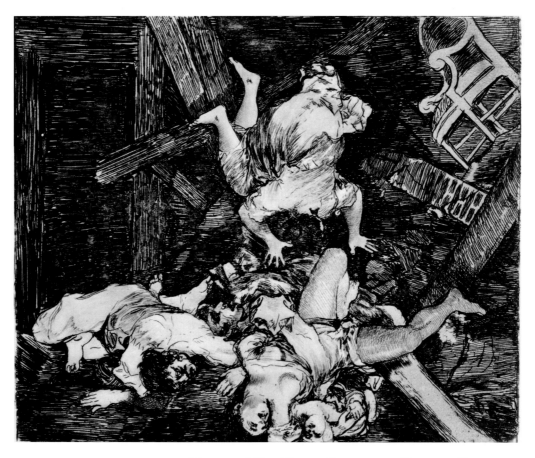

49. RAVAGES OF WAR. *Disasters of War*, No. 30. Begun 1808 (?) 5 × 6⅛"

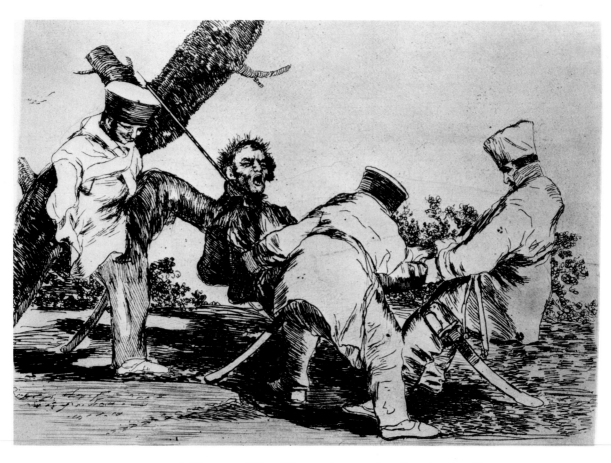

50. WHY? *Disasters of War*, No. 32. Begun 1808 (?) 5⁷⁄₁₆ × 7⁷⁄₁₆"

COLORPLATES

Painted 1777

THE PARASOL

Oil on canvas, 39 × 59¹/₈″
The Prado Museum, Madrid

Owing to the meticulous organization of Spain's Royal Patrimony, we now have almost all of Goya's tapestry cartoons and the corresponding documents. In this way the chronology, economic data, and other related facts concerning these works are precisely established. The cartoons were executed from 1775 to 1780, and from 1786 to 1792. They were painted in oil on canvas after preparatory sketches and drawings. When we analyze the cartoons from the first period, particularly those delivered by Goya in August of 1775, we see a renunciation of the spontaneous liveliness characteristic of his earlier paintings. This must have resulted from the restrictions imposed by Francisco Bayeu. The superiority of Goya's cartoons over those concurrently commissioned from Ramón Bayeu and other painters is, nevertheless, overwhelming. Beneath the pleasant, conventional compositions, there appears, instead of Goya's natural violence, the strength and novelty of his expressive means. The enveloping space achieved first in the decorations of the Aula Dei redeems the iconographic vulgarity imposed on the artist.

Goya's own temperament seems to return in the cartoons commissioned in 1776, though it is somewhat obscured by a mannered aspect and a preciosity that endows the characters with a certain doll-like appearance. This feature is most apparent in the *Dance on the Shores of the Manzanares;* beneath the stiffness of the figures, however, may be seen the lessons learned from Velázquez. It was during this same year that Goya completed his etchings after paintings by the great master of Seville. Descriptive naturalism dominates in the cartoons of 1777, most carefully executed with very rich color harmonies and increased interest in tactile qualities.

The Parasol is perhaps the best of the cartoons delivered in this year, although the work may perturb today's viewers, who have seen imitations by Goya's many followers. Figures having ample contours persist in *The Parasol,* their broad faces only slightly particularized in feature. There is also a vaporous treatment of details, and a taste for the sumptuous in color, light effects, and fabric qualities. Excesses in this respect often impair the work of Goya's followers. Such paintings as *The Parasol* illustrate the degree to which Goya could achieve success in themes he had no spontaneous feeling for, but nevertheless bent to his will. The concept of an enveloping space that is moving upward and forward is also maintained; its effectiveness is augmented by placing the source of light below the figures. Goya indicates the forms and outlines of accessory elements very simply, thus making of them a kind of screen before which the human elements in their color and light acquire high relief.

48

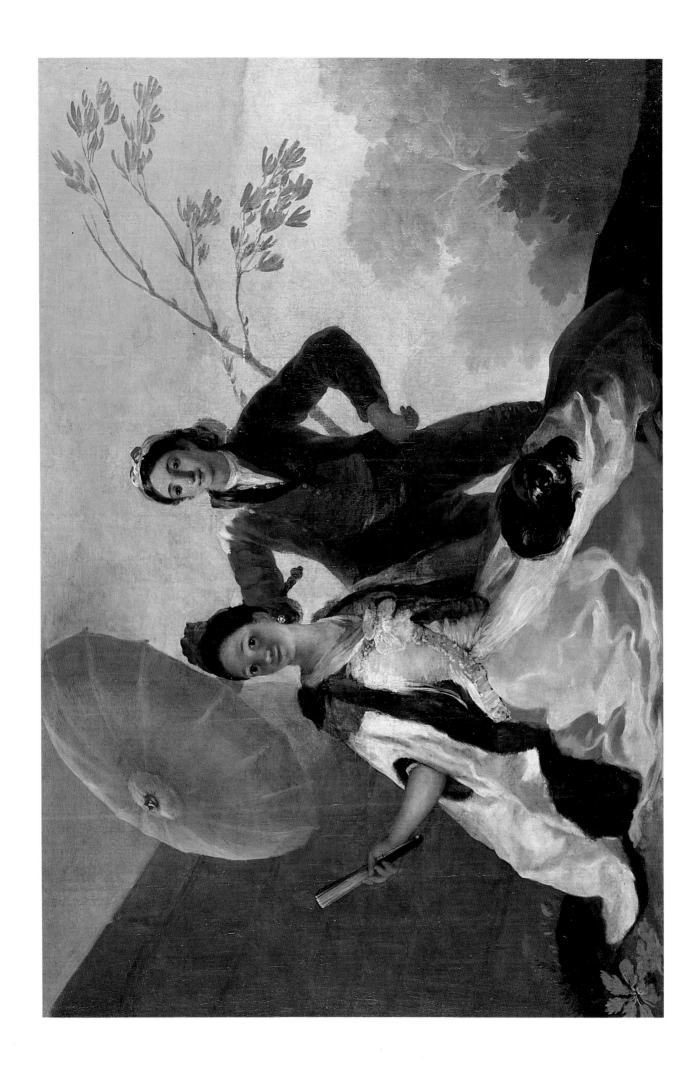

Painted 1780

THE WASHERWOMEN

Oil on canvas, 79⁵/₈ × 42″
The Prado Museum, Madrid

Goya delivered several of his most famous tapestry cartoons in 1778. Among these is *The Crockery Seller*, an admirable composition expressing the contrast between two very different worlds, that of the crockery merchants and their clients, and that of the nobles who pass by in their coaches unmindful of the scene. The delicacy and variety of color harmonies are extraordinary. *The Blind Guitarist*, also of this year, exhibits an exceptional boldness of execution. The face of the central figure is resolved with varying brush strokes that presage the expressionist procedures of twentieth-century art. After completing only a few cartoons in 1779, Goya resumed full activity in 1780. His greatest attention was now given to composition and to a concern for correct rendering of distances.

Outstanding among the cartoons of 1780 is the beautiful and brilliant *Washerwomen*. In this cartoon appear some of the contradictions of spirit that are frequent in Goya's art. Thus there is the delightful landscape, idyllic but stormy. A line of clothes hangs drying on the horizontal branch of a tree. Before it are the washerwomen: one is sleeping with her head on the lap of another; she, with her companion, pretends to frighten the first with a lamb; in the rear are two more women. The faces of the three principal figures and the technique with which they are treated show Goya's effort to differentiate each one and represent her momentary expression. Thus the face of the sleeping woman is cast in shadow, suggesting the mystery and withdrawal of the dreamer. The center figure exhibits one of those faces so typical of Goya: hardly constructed on reality, the volume seems miraculously obtained, while the whole presents a fluid appearance. Goya possibly intended to synthesize the expression and movement through blurring the form. On the other hand, the face of the woman at the left is firmly modeled and the features are sufficiently particularized.

The figures in the second plane are also of great interest, particularly that of the woman carrying a mountain of wash on her head. Thus, in compositions alternating between the popular subject and the portrait, Goya sharpened his faculties of observation and intuitive psychology. Several cartoons of the same year, which include child-like figures, show Goya capturing the soul of the child, with its mixture of candor and mischievousness.

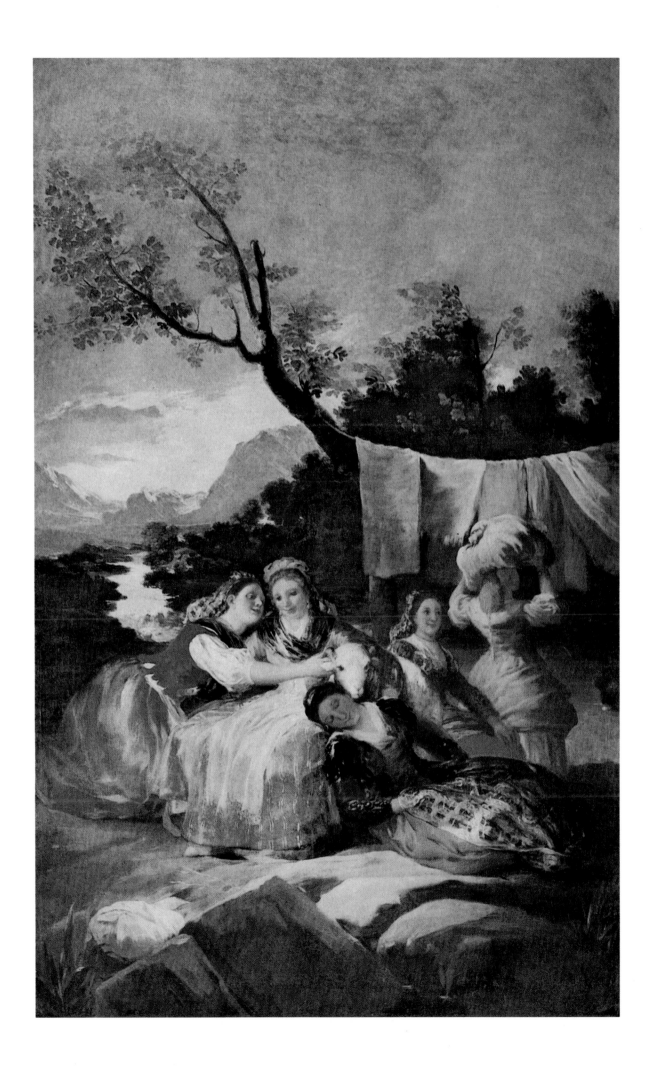

Painted 1783

PORTRAIT OF THE COUNT
OF FLORIDABLANCA

Oil on canvas, $81^1/_2 \times 42''$

Banco Urquijo, Madrid

The king's chief minister stands in a frontal position near a table on which are placed papers and a clock. His secretary appears in the background behind the count and the table. An oval portrait of Charles III hangs on the rear wall. In the left foreground, Goya has represented himself, full length and in profile. He offers a painting to the count, probably the head study of the sitter that always preceded the final execution of a portrait. Goya's interest has been directed toward achieving a good likeness, rendering the qualities of the sumptuous outfit—particularly the bordered waistcoat—and capturing the mien of the subject, which conforms so fully to the spirit of the epoch. Within the academic correctness of the objects represented there is a further rigidity that recalls certain figures of the tapestry cartoons. Similarly, a fidelity in the quality of drawing does not permit the picturesque accents found in Goya's more characteristic works.

The portrait, particularly when presenting a powerful and influential person, evidently did not lend itself to temperamental creations, nor even to Goya's unconscious desire to practice art for art's sake. However, in other portraits, Goya obtained effects of higher quality with more humanization of the subject. The Count of Floridablanca appears as a well-adorned, great nobleman, whose fine and regular features contrast with those of his secretary, who is more vulgar in appearance. The count's tall figure makes Goya's seem smaller. The almost hieratic pose, the count looking ahead without heeding the painter's gift, creates an uneasiness that is stressed by Goya's own attitude, which is somewhat awkward—as if Goya were caught motionless at an inopportune moment. The shadowy painted portrait of Charles III appears to denounce Goya's insecurity and timidity. In this work, designed to impress his client, Goya has tried to surpass the pictorial concept established by Mengs. Goya's struggle to hide his talents behind this forced technique, and this rococo ensemble placed in a theatrical setting, is truly pathetic. Thus, in this portrait, Goya seems to subject his own dramatic sense to the dominant pictorial mode of the court.

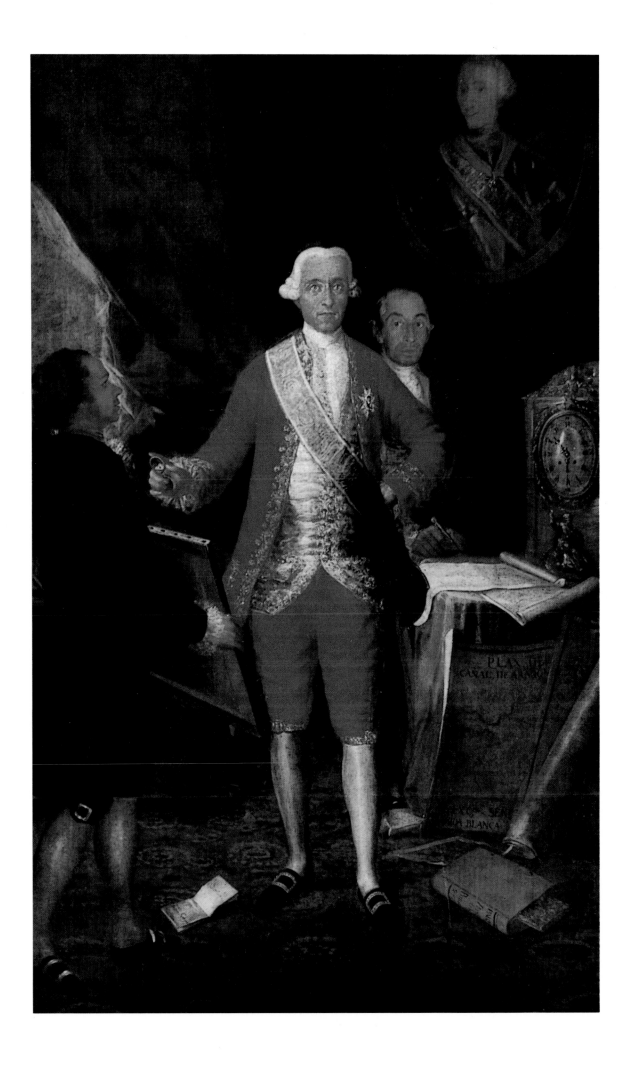

Painted 1787

SAINT BERNARD BAPTIZING
A KNEELING MAN

Oil on canvas, 112⁵/₈ × 63"
Church of Santa Ana, Valladolid

This painting is one of three that Goya executed for the Church of Santa Ana in fulfillment of a royal commission. The hagiographic subject struck a deep chord in Goya's temperament, as did the full and rich Spanish tradition of the theme and its sentiment. Thus Goya could develop the subject conscientiously. The aesthetic of the three paintings fully reflects the epoch in which they were created, yielding a synthesis between the spirit of the tradition and the realist current that would evolve during the nineteenth century. The theme, characters, and action of great hagiographical paintings of the late sixteenth and the seventeenth century are visible. Their conceptions are preserved although they are treated with a refinement of means, analysis of visual truth, and a very superior pictorial ambition. Zurbarán's work comes closest to providing a precedent, particularly for the figure of St. Bernard. Study of Goya's work, however, makes evident his advance over what had developed earlier.

In the *Saint Bernard* composition, Goya achieves a monumentality of form that not only corresponds to external grandeur, but expresses particularly the feeling of the supernatural. To give coherence and to attain maximum effects of harmony and contrast, Goya places the three figures close together with a minimum of space separating them. This is most important, for it unifies the action and, above all, the tectonic form of each figure, yielding an expressive and powerful effect. The kneeling man, almost in profile, is not set against a neutral or vacant background, but against the white habits of the saint and his acolyte. Two sources of light appear to illuminate the subject: a natural source somewhat at the left of the spectator, and a supernatural light emanating from the luminous aureole surrounding the head of the officiating saint. Slight differences of distance between the figures permit Goya to establish a very subtle and rich harmony of hues.

In the drawing may be seen Goya's extraordinary dexterity in resolving difficult foreshortenings and in giving interest to each area, harmonizing the individual formal elements. For example, the area somewhat at the left of the center, with the head of the baptized man and the acolyte's hand holding the fine earthenware pitcher, is stupendous. This *Saint Bernard* canvas is an important landmark in the history of Spanish religious painting, not only for its judicious tactile quality and subtle tonalities, but for its spirituality as well.

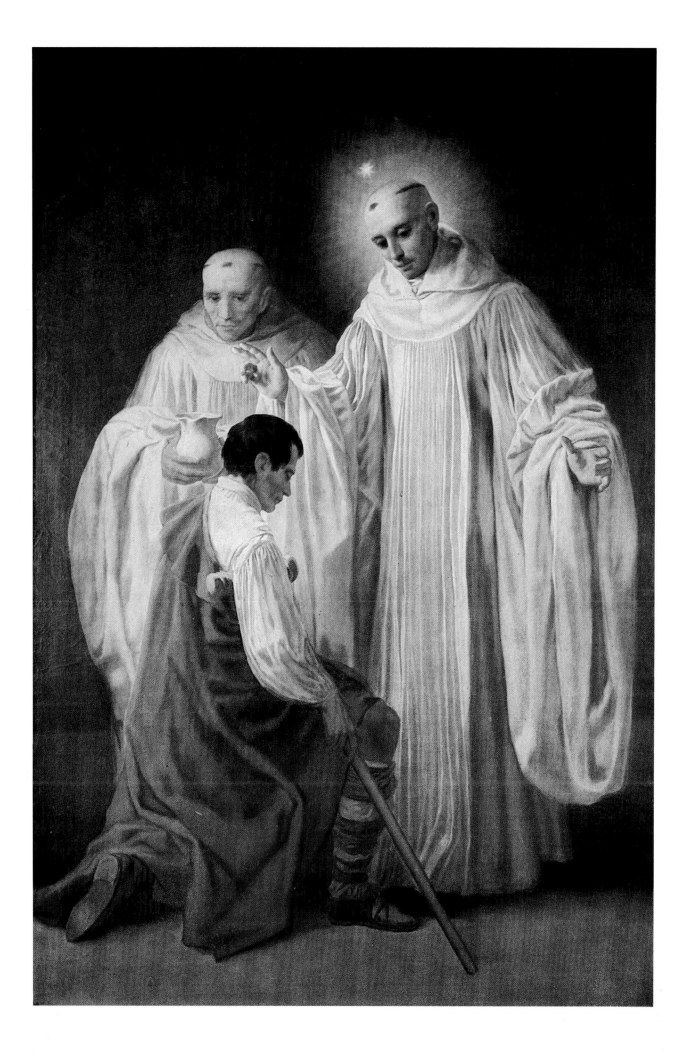

Painted c. 1786

PORTRAIT OF THE MARQUESA
DE PONTEJOS

Oil on canvas, 83 × 49⁸/₄″

National Gallery of Art, Washington, D. C. (Mellon Collection)

The marquesa is seen full length, with the cold and regal air assumed by great ladies of the eighteenth century. No communication exists between the artist and his model in this Mengs-dominated aesthetic. The importance of feeling is itself translated into a benumbed, distant attitude. Nevertheless, Goya strengthens the image by means of a clear, pleasant palette and by re-creating details of a feminine sensuousness of appearance, thus compensating for the then-fashionable coldness and the conventional, mask-like face. In the usual manner of the dress of the time, the body appears ruled by the outfit, the lines of which exaggerate or modify the natural figure. Thus one may observe the large hat above a massive coiffure, tied with ribbons at the nape of the neck; the very tight bodice with a collar of flounces and lace; the long, pleated skirt with its overskirt gathered at the knee to form complicated, capricious, and very full folds, embellished with ribbons and flowers. In her right hand, the marquesa holds a pink carnation. Before her, there is a small dog—a detail frequent in Goya's portraits. The landscape setting consists of a conventional background with blurred masses of trees, and delicate sprigs of grass in the foremost plane. Goya's characteristic firmness of drawing is evident, though masked by the smoothness of form and daubs of color, as well as by somewhat arbitrary and subtle reflections of light. As in similar works, the full variety of Goya's range is to be seen, a range as broad as the artist's feeling, extending from the violent and the fleeting to the most painstaking technique of the miniaturist. In color, the painting manifests a delicate dexterity with smooth, shaded blends of gray and rose hues that harmonize with the green and yellow tints of the foreground and background. The figure's tense verticality imposes on the portrait its dominant character. But sensitive details of considerable gentleness and refinement lessen the austerity of the image.

A relationship may be observed between this painting and certain of the figures and locales of the tapestry cartoons. Color, gradation of the planes, and the *sfumato* qualities of the background are similar in both the portrait and the cartoons. The rendering of the sky merits attention, its greenish-grays and blues enlivening the rosy colors of the flowers that are both carried and worn by the marquesa.

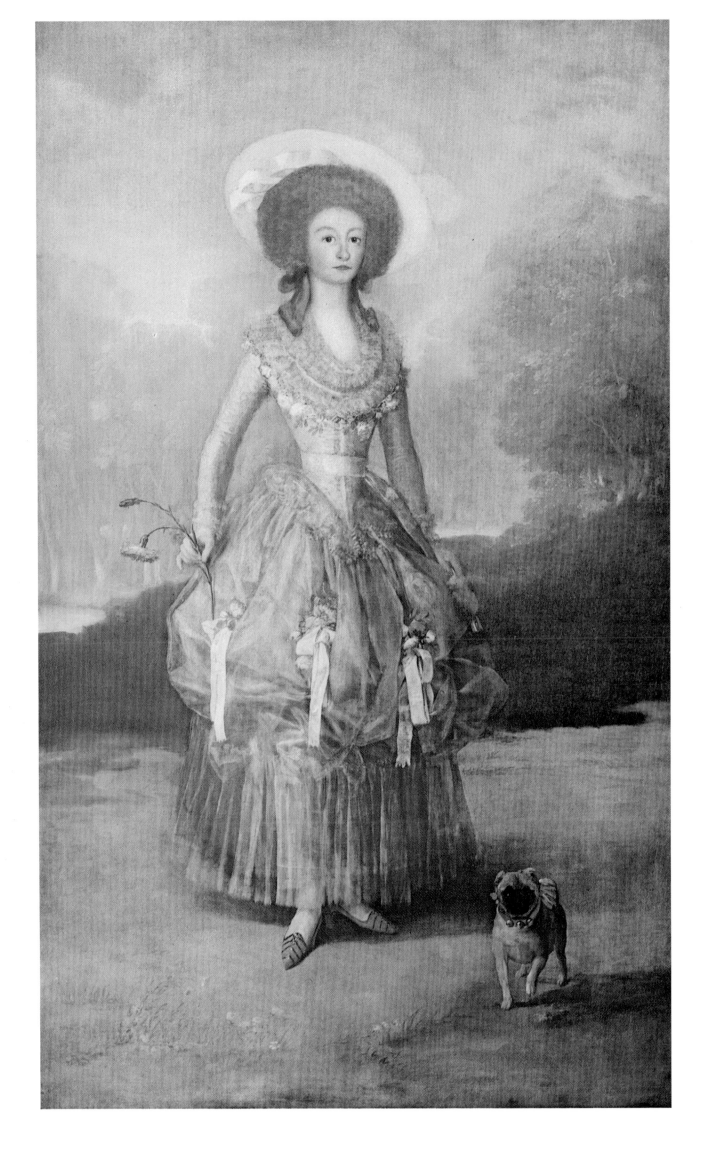

SAINT FRANCIS OF BORGIA EXORCISING A DEMONIZED DYING MAN

Oil on canvas, figures lifesize

Cathedral, Valencia

This work, commissioned by the Duchess of Osuna and executed in 1788, is one of a pair, the other illustrating St. Francis' farewell to his family. A sketch in the collection of the Marquise of Santa Cruz, Madrid, shows the bedclothes in disarray, suggesting the violence of the agony; beneath the voluminous background draperies that partially cover a round window, indistinct, diabolic monsters appear. The rigid body of the demonized man is almost completely uncovered, and one of his feet extends beyond the bedclothes. The dying man is looking at the crucifix held in the saint's right hand; the left hand of the saint is raised in a gesture of horror. The painting is as violent as the theme. Goya here glories in the power of his analytical resources.

Almost all the elements of the sketch are retained in the final work, though they are made clearer. The atmosphere has calmed, the contrasts are defined, and the depth of the brush strokes varies in proportion to the importance of the form. The background loses pictorial intensity, while the figures acquire greater clarity. Forms have a more sculptural character and contrasts in tone are intensified. The body of the demonized man appears whiter, particularly in the admirably interpreted torso; similarly, the saint's hands are whiter, underlining the feeling of piety mixed with horror. Behind the body of the dying man, monsters emerge—the first to be seen in Goya's work, presaging those in the world of the so-called black paintings. Their horrible faces, one human and one animal, draw near the rigid, cadaverous face of the agonized man, whose face, moreover, with its ill, tense expression and strong shadows and strokes on the eyebrows and eyelids, is pictorially the most successful passage of the painting.

Contrasted with this distended face is the frightened but nevertheless benevolent face of the saint, bathed in a supernatural light. Doubtlessly, the compositional conception is powerfully illustrated, but Goya's mastery gives plastic interest to each area and detail. As in the majority of his works, there is a certain disregard for the background, which is rather summarily treated. All animation is concentrated in the figures and in the fabrics of the foreground plane.

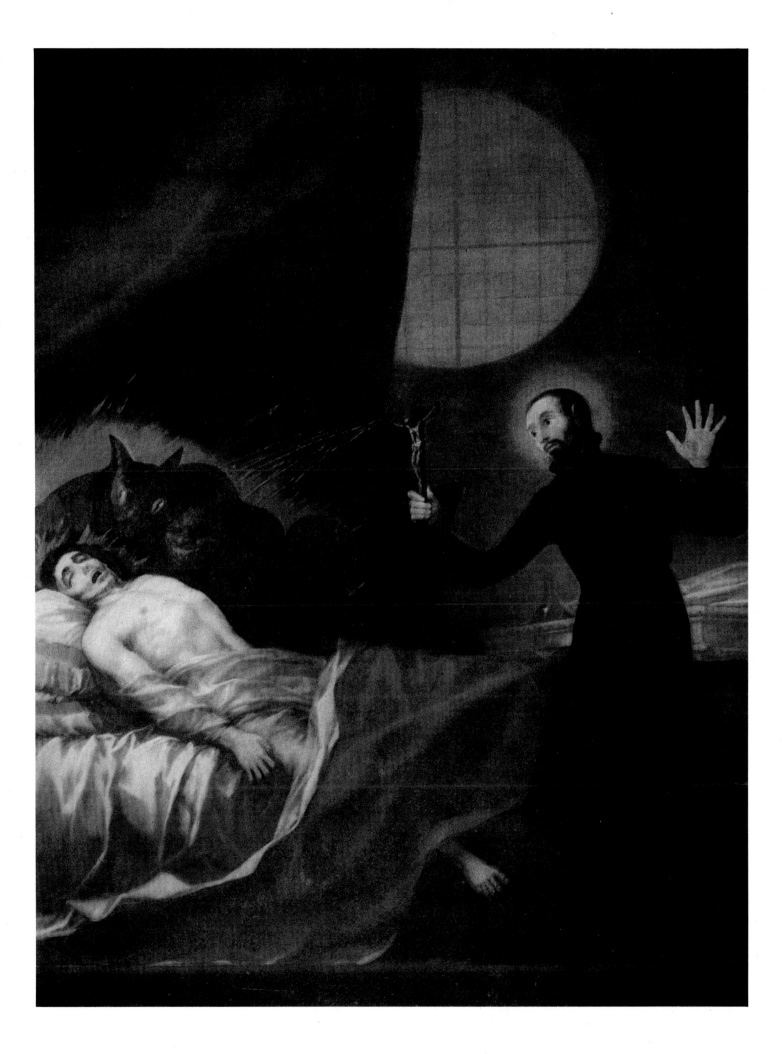

Painted 1788

PORTRAIT OF DON MANUEL OSORIO DE ZÚÑIGA

Oil on canvas, 50 × 40"

The Metropolitan Museum of Art, New York (The Jules S. Bache Collection, 1949)

The features that initially captivate the spectator in this portrait are the child's beauty, the gentle modeling, and the delicious effect of the red outfit. The large, chestnut-colored eyes, the silky hair, and the surprisingly simple rendering of the skin vividly contrast with the brilliant costume, which is adorned with a white lace collar and tied with a silken cummerbund of a similar hue. This basic harmony is set off against the grays and greens of the animals and objects that appear at both sides of the model. However, the dominant achievement in this canvas is found in the contrast between the living, though static, form of the boy and the latent force of the effects of light and space. Without any element indicating surroundings or decoration, the background serves to establish the floor and wall, differentiating the two only by the somewhat deeper yellow of the floor. However, a new character and animation are given to the painting by the light which forms a sort of aureole around the child's head, and also gives prominence to the lower left foreground area, where the bird is holding a small card in its beak.

Also typical of Goya is the group of three cats that eye the bird, as if in the hope of capturing it. Excellence of execution abounds, the particular beauty of the red fabric enlivened, as it were, by the less specific gray-green tones of the background. Greater brilliance is also brought out in the scarlet red by resounding white notes. Perhaps owing to Goya's aesthetic inclination of the moment, movement is here restrained and reduced to its minimum expression. Goya is equally successful with the sitter's child-like appearance, very different from that seen frequently in the young protagonists of many of the tapestry cartoons. Here, an inner life becomes visible in the tightly pressed lips and in the sharp, forward glance. Manuel Osorio posed for the artist with the distant indifference of many of the period's aristocratic sitters. However, at his tender age, he had not yet learned to approximate their benumbed and stiffened mien.

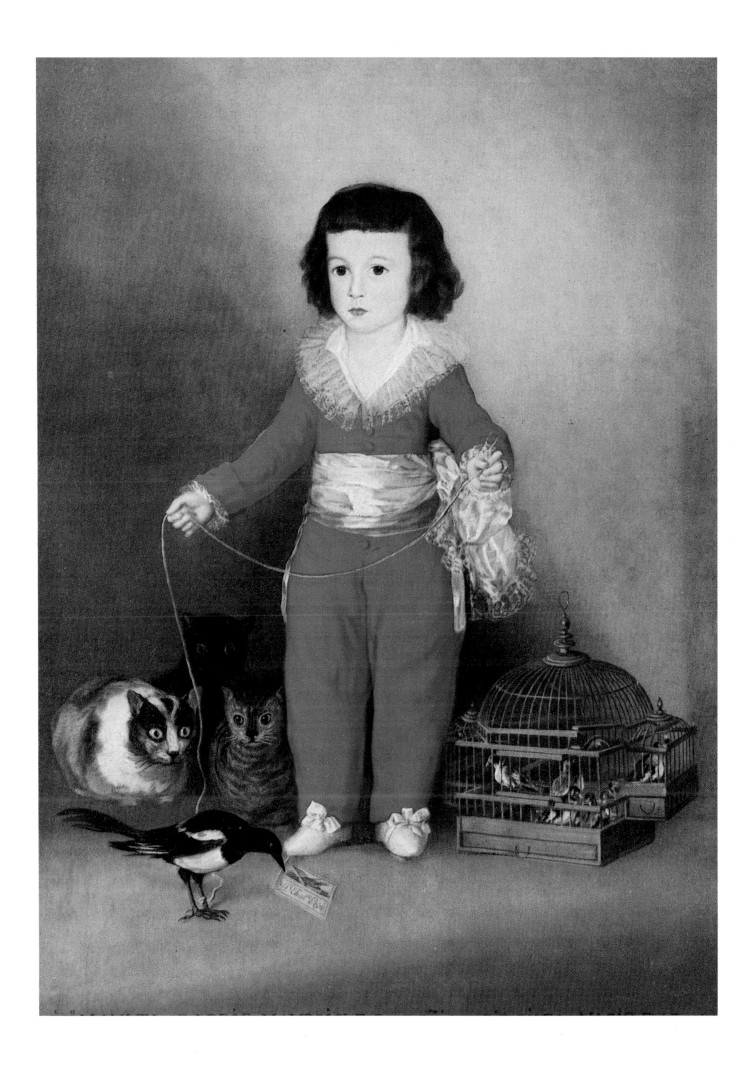

Painted 1789

THE DUKE AND DUCHESS OF OSUNA
WITH THEIR CHILDREN

Oil on canvas, 88⁷/₈ × 68¹/₂"

The Prado Museum, Madrid

The dominant impression offered by this splendid group portrait is that of the gray-blue tints that pervade the entire canvas. Thus, it seems to follow within that tendency toward the monochromatic, which at times emerges in Spanish art. The seated duchess, in a wide-skirted dress, appears somewhat rigid, her right arm turned sharply at the elbow. Standing somewhat to the rear, the duke bends slightly forward, assuming a protective and gracious stance. Three standing children are placed in almost exact symmetry, one at the center and the others at the sides; the daughter holds her father's hand and the son stands close to the duchess. The smallest child, perhaps two or three years of age, is seated on a large cushion and holds the string of a toy carriage in his hands. A small, curly-haired dog looks playfully toward the girl.

Respect for a certain hierarchism is joined in this portrait with the desire for an affectionate, familiar expression. And it must be noted that Goya succeeded perfectly in this synthesis. Without falling into bourgeois sentimentalism, Goya renders the familial feeling of the sitters, while, nevertheless, making the spectator aware of a slight suggestion of distance in the relationship of the models to the viewer. The duke shows the resplendent golden trimmings of his dress coat and vest, as well as the hilt of his small Lavallière dress sword. The duchess is seen in a vaporous skirt, and a wide, lace-flounced collar above a tightly fitted waist. The children wear similar, though smaller, collars.

In this painting, Goya resumed the impressionistic and synthesizing technique in which he combined, with his proverbial facility, wonderful luminous effects— poetic though conventional to a certain degree—with subtleties of form and suggestions of tactile quality. As noted above, a bluish-gray hue dominates the entire composition. However, this hue exists together with rose-white, pallid flesh tones, in the midst of which stand out above all, and almost foreignly, the black pupils of the intensely gazing eyes of the sitters. This portrait of the Osuna family is one of Goya's most pleasant paintings. It is not lacking in mystery, achieved particularly in the contrast between the *sfumato* qualities of the total composition and the precisely pointed, dark eyes.

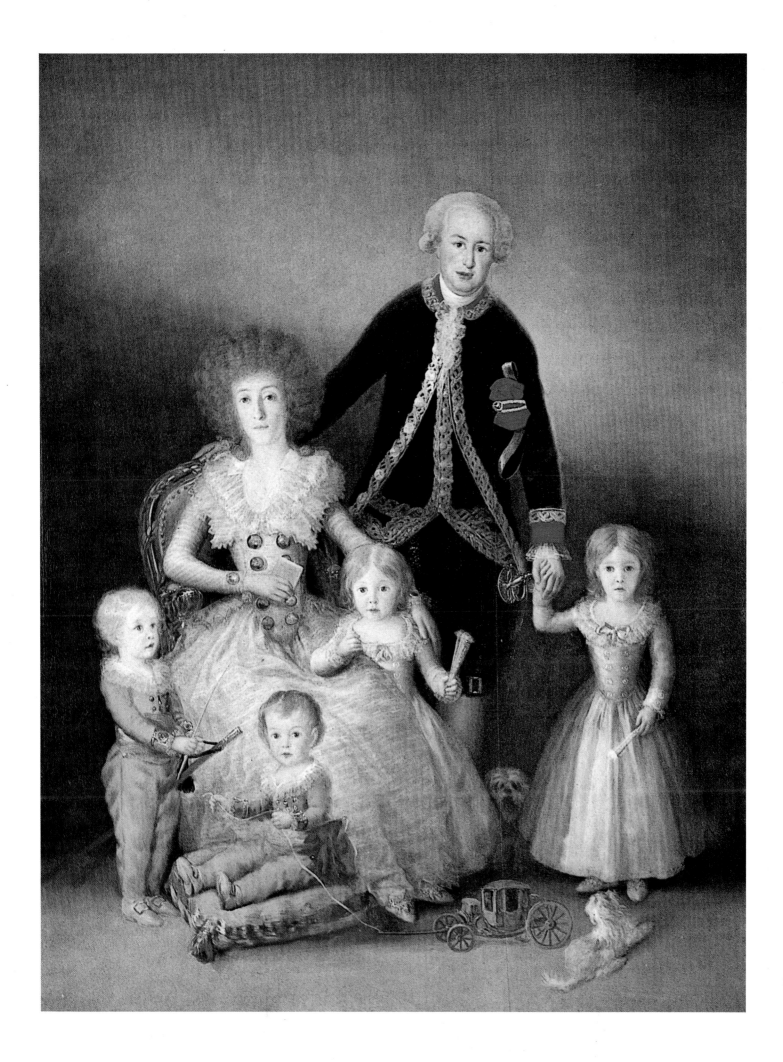

Painted 1792

PORTRAIT OF SEBASTIÁN MARTINEZ

Oil on canvas, 36⁵/₈ × 26⁵/₈″

The Metropolitan Museum of Art, New York (Rogers Fund, 1906)

Moving away from the conventional formulas established during the last third of the eighteenth century in Madrid by the Bohemian, Mengs, Goya seeks new forms in his portraits, each time nearer to life and to reality. In order to achieve this, he placed the model as close to the viewer as possible, and chose a point of view below the sitter. In so doing, he retained a certain freedom of attitude, so that the person was portrayed in conformity with his character. Naturally, formalism is most evident in conventionalities of dress—or so it appears, due to the strong contrast with our time, which is much simpler in its demands in this respect. In the faces of the models, however, there is an admirable fidelity to eternal human truth. In the portrait of Sebastián Martínez, the seated model is turned to the left, though his face is almost frontal. The serene forehead, clear glance, very marked cheekbones, and large, well-drawn nose and mouth create an attractive and very virile face, the effect of which is scarcely disturbed by the clearly rendered peruke.

Form appears to have been treated with greater firmness than in other works, and the contour lines are drawn with clarity, lacking the *sfumato* quality so frequent in Goya's art. The brilliant, striped dress coat, with abundant blendings of lights, shades, and reflections, is of great beauty. The white tie, the letter held in the sitter's right hand, and the bright trousers with brilliant buttons on the knee are in contrast with the dark background.

Pictorial qualities abound in the entire image, with nothing treated casually or in a routine manner. In particular, the modeling of corporeal volume is evenly correct, despite the distinct textures of the wearing apparel. This was apparently the final portrait of the second stage of Goya's career, abruptly terminated by the grave illness that left him deaf for the remainder of his life.

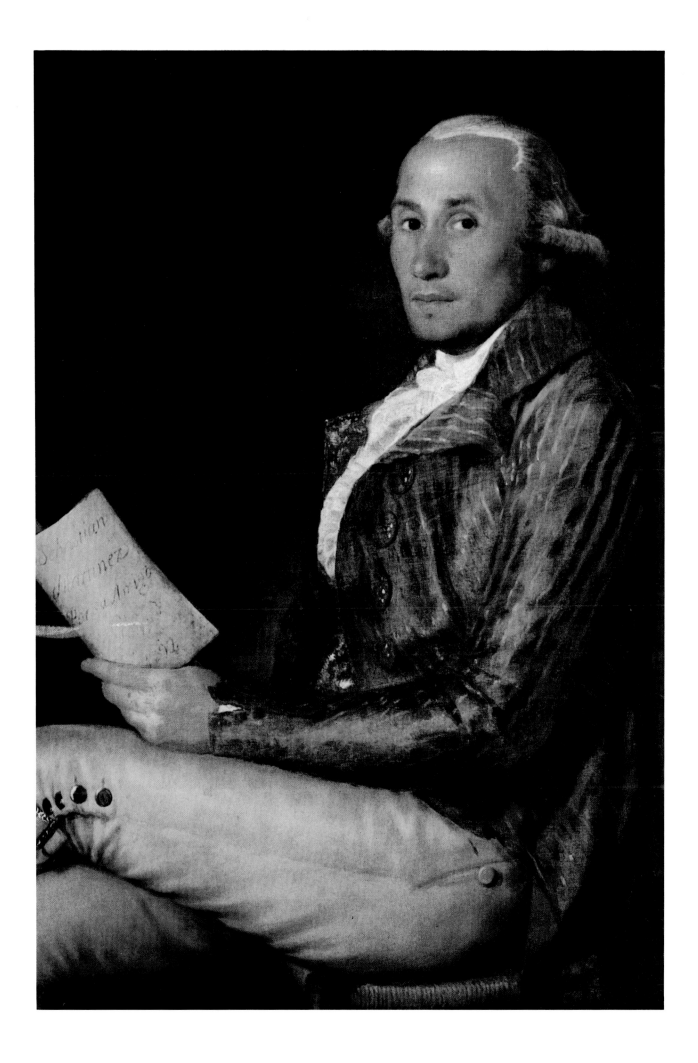

Painted c. 1793

THE FIRE

Oil on tin plate, 19³/₄ × 12⁵/₈"
Collection Countess of Campo Giro, Madrid

This scene probably represents an exterior view of a burning hospital; groups of men rescue swooning men and women from the smoke and flames. Like other similar scenes by Goya, *The Fire* has a pointed narrative feeling. The effect of a scene captured directly from reality is produced not only by plastic qualities, but also by a successfully achieved atmosphere. Seeking unification, Goya entirely subordinated the separate characters to the collective unit. A group of human beings rushing to escape the tragedy appears just behind the foreground plane, beneath a cloud colored by reflections from the great blaze. Rhythms are charged with violence, achieved not so much by the fluidity of technique, which liquifies linear contours in favor of masses, as by the interweaving of individual figures in a strongly united manner. The reddish lights of the fire are masterfully formed.

No element of the surroundings is specified, but rather only an intense and formless smoke-enveloped light that glides over the mound of people attempting either to flee or to rescue survivors. Despite the slight distance between the foreground figures and those in the rear, a gradation of planes is sufficiently well defined in accordance with Goya's norm, as in the El Pilar Cathedral vaulting decorations. These effects of depth are among the best in Goya's work. *The Fire* certainly formed a part of a series dedicated to the representation of catastrophes. A shipwreck scene of identical dimensions, also painted on tin plate, belongs to the same series. Judged from the style of these paintings, they would have been executed during Goya's convalescence from the illness he suffered early in 1793.

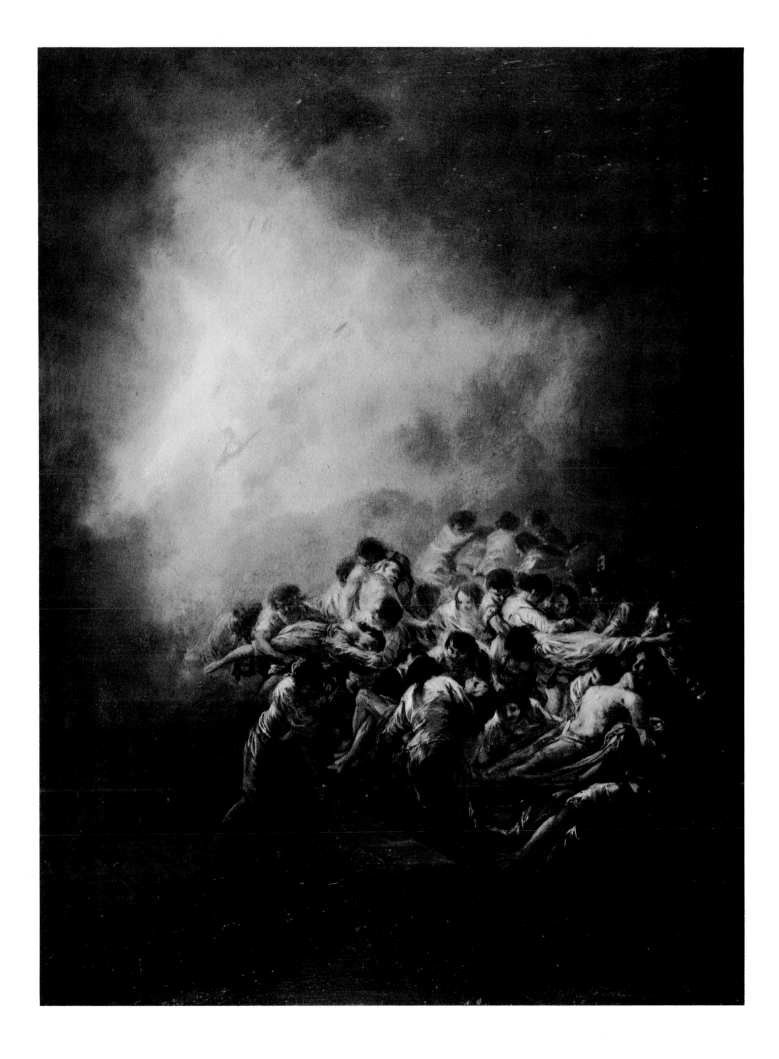

Painted c. 1793

THE INCANTATION

Oil on canvas, 16¹/₂ × 11³/₄″
Lázaro Galdiano Foundation, Madrid

A group of witches surrounds a frightened woman, who kneels in her chemise before them. Of the black witches, one holds a basket of infants, one torments an infant, one gestures hideously, and one reads the incantation by the light of a sputtering candle. The central figure in yellow is casting the spell. It is twilight; above the group a crescent moon floats in a sky made turbulent by flying owls, and a demon completes the scene of conjuration. The mountainous landscape, barren of vegetation, is nearly deserted.

Goya's latent expressionism is best served by a conventional tactile handling. In the witches' figures, arranged in a half-circle around the woman, Goya distinguished the planes by varying the contrasts of color and light, and by placing the group on a plane that is inclined upward. The expressive factor is very sharp, reaching a climax in the insane demeanor of the yellow-clad figure of the conjurer stretching her hands toward the cowering woman.

Goya's brush strokes are free and rapid, not insistent on form. There is bold line in the silhouettes of the black witches, especially the bat-winged headdress of the tormenting figure. The artificial light half-drenches the forms it illuminates, including the face of the flying demon who waves two bones above the chanting witch. The painting is a synthesis of daring pictorial devices and sharp narrative passages.

The Incantation forms part of a small group of paintings which Goya may have executed during the period of introversion he underwent following his grave illness of 1793. It was acquired by the Duke of Osuna in 1798. A majority of the themes in this series anticipate those in the wall paintings of the Quinta del Sordo, Goya's country house; they are also reflected in the etching series published in 1799, *The Caprices*.

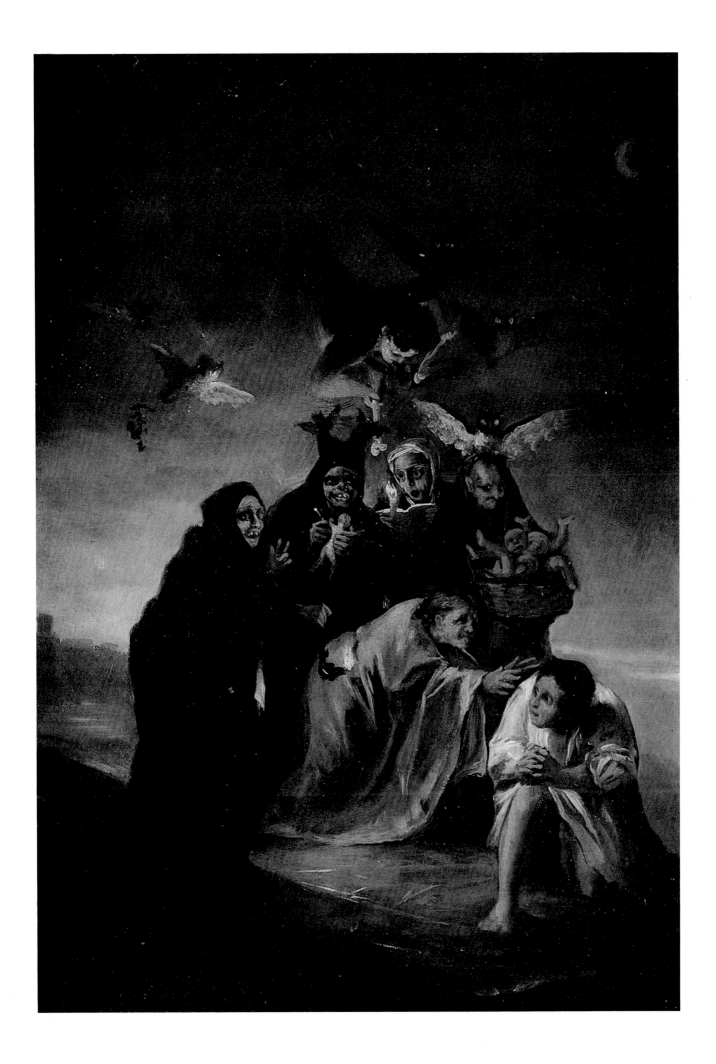

Painted 1797

PORTRAIT OF THE DUCHESS OF ALBA

Oil on canvas, 83 × 57⁷/₈″

The Hispanic Society of America, New York

This admirable portrait is also a magnificent painting, abundant not only in the artistic features present in the subject, but in the artist's independent contributions as well. The duchess is shown standing, a certain rhythmic tension in the outlines of her body causing the pictorial design to appear somewhat aggressive. The twist of her torso, swathed in dark hues, makes her face appear slightly turned to the left. A black lace mantilla envelops and outlines her head, and accentuates the blackness of her hair, her strong eyebrows, and her imperious glance. Her left hand is placed on her hip, with her elbow projecting backward behind the outline of her bosom. Her right arm hangs loosely, its white hand prominent against the dark, opulent skirt. The figure is terminated in the duchess's sharply pointed shoes.

In this portrait, Goya returns in some degree to the formal attitude seen in some of his earlier feminine figures, in the portraits and in the tapestry cartoons. The simultaneously vigorous and smooth technique in the face and hand, knowingly accented with light and shade, contrasts with the more impressionist rendering of the costume. This impressionism is best seen in the headdress, where all linear elements are indicated with unusual strength, as is the tufted skirt. The figure is placed against a sketchily painted background, which emphasizes the corporeal form and the pictorial qualities which it inspires. Many of these qualities maintain an anarchical freedom, forming part of the total sense of the image. Scrutiny reveals independent elements that do not seem intended to imitate the materials to which they refer. In certain other details, however, Goya relied on an over-careful, exact transcription of various qualities. This is seen in the trimming of the duchess's pointed shoes and in the two small finger rings on her right hand, one inscribed "Alba" and the other with Goya's own name. On the sand, as if written by the duchess herself, is the inscription "*Solo Goya*" ("Goya only"), which would seem to confirm the traditional account of the idyllic relationship between the painter and the duchess. Apparently Goya painted this portrait for himself; the painting did not leave his hands during the lifetime of the duchess.

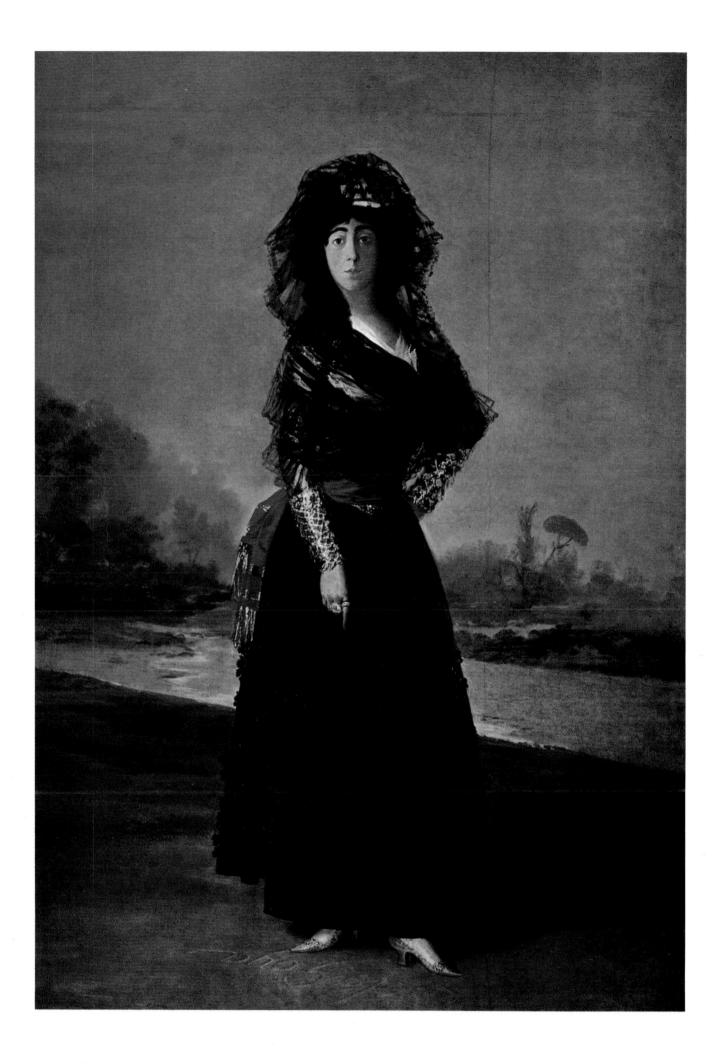

Painted c. 1797

ALLEGORY OF SPAIN, TIME, AND HISTORY

Oil on canvas, 121 × 94³/₄″

National Museum, Stockholm

This large composition is doubtlessly one of Goya's best works. It was probably paired with the large *Allegory of Poetry*, which Goya painted around 1797 for the decoration of Godoy's Madrid palace. The *Allegory of Spain, Time, and History* exhibits qualities not usually seen in Spanish painting, such as imaginative compositional freedom binding the real and the imaginary, and an almost titanic monumentality balanced by lyricism of form and light. The three figures appear solidly substantial, though without either monotony or heaviness. This effect is attained by a feeling for the space that revolves about each figure, and by reflections of light contributing to free circulation of the spectator's glance. One's gaze is led, not only by visible passages, but also by the enveloped forms submerged beneath them. The compositional scheme is a large triangle, indicated by the line of the inclined tree trunk and that of the right wing of the personification of Time. Divergencies of a smaller triangle are centered in the allegorical figure of History, seated in the foreground. An ample space extends above the heads of the figures.

In technique, this allegory is at once full, rich, and mixed, while yet simple and contained. Slight deformations modify some details of form in order to suggest effects or to call attention to fleeting lines. Tactile precision is elusive. An even *sfumato* envelops compositional elements in its atmosphere, intimately uniting effects of light with those of the quality of materials and modeling of the forms. In the face of the allegorical representation of Spain, the archaic, Madrid streetwalker types of the tapestry cartoons have been superseded. Although an impersonal beauty unfolds, the extreme refinement of the face and its features offers great interest. The dress worn by "Spain" is one of the best pictorial fragments of the work, its folds crumpled in the then-fashionable high waist with other, less marked, large pleats above the hips. Brilliancies and reflections are intensely rendered without giving in to a predilection for the sensual.

Linear effects are rare, as always in Goya's work. The contours of the left leg and foot of the seated figure of History are scarcely defined; instead there is simply a white form of pearly flesh color. Despite placement in the shadows, the very precise drawing of Time's virile body is clearly evident. The foreshortened view of his upturned head is masterful in form and intensity of expression. The sentiment that animates Time makes him look more like a Miltonian fallen angel than a deity from pagan mythology.

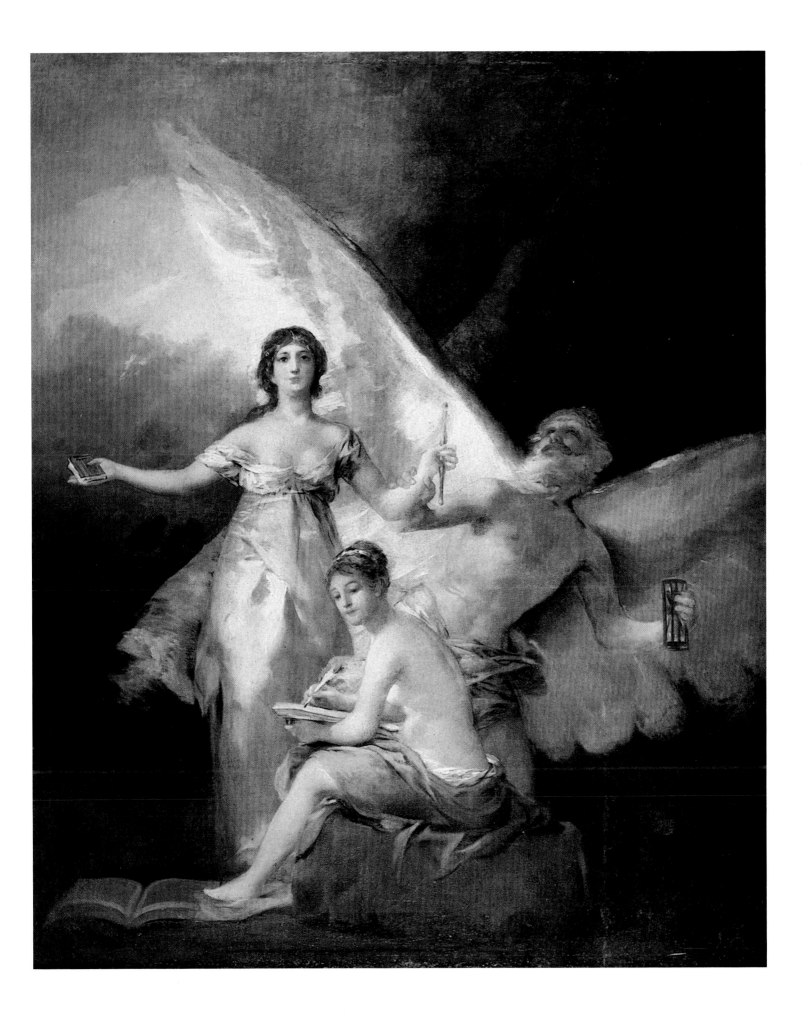

Painted 1798

PORTRAIT OF DOCTOR PERAL

Oil on canvas, 36¹/₄ × 24¹/₂"

National Gallery, London

In this portrait of 1798, the subject regards the viewer in a lofty and almost aggressive manner. The somewhat foreshortened, seated figure faces right, his head and neck slightly turned, emphasizing the movement that accentuates a facial deformity. The aged Dr. Peral's long, disheveled hair is silvery-gray. He wears a greenish-gray dress coat and a white vest with an ornamental floral motif similar in hue to the outer jacket. His right hand is concealed in the vest, while his left rests on his thigh. Despite Goya's undeniable ability to represent hands, those of many of his models are hidden. According to tradition, the price of a Goya portrait was substantially increased if the subject wished his hands shown. On several occasions, the painter declared that the painting of hands caused him more labor than that of painting the head. Dr. Peral's large-boned face has marked cheekbones, chestnut-colored eyes, and a large, though thin-lipped, mouth. Goya's brush strokes are particularly expert in the vest, where they are not as subordinate to specific portrait objectives as in the rendering of the head. Contrasts of tone model the folds of the garment and the torso. They simultaneously yield excellent tactile qualities of cloth and very beautiful reflections of light.

Luminous iridescences of color are thoroughly blended in the entire composition, from a very pale green to the dark hues of the shoulder and back area. A somewhat arbitrary lighting causes the sitter's back to stand out from the visible segment of the chair. A play of lights in motion also gives interest to the waist area. The face is particularly worthy of attention, both due to the expression noted above and to the purely representative values of each part and of the total image, which appear to possess life and movement. Areas of shadow at the sitter's back, and his left arm, almost completely in darkness, seem to unite him with the solid-hued, somber background.

74

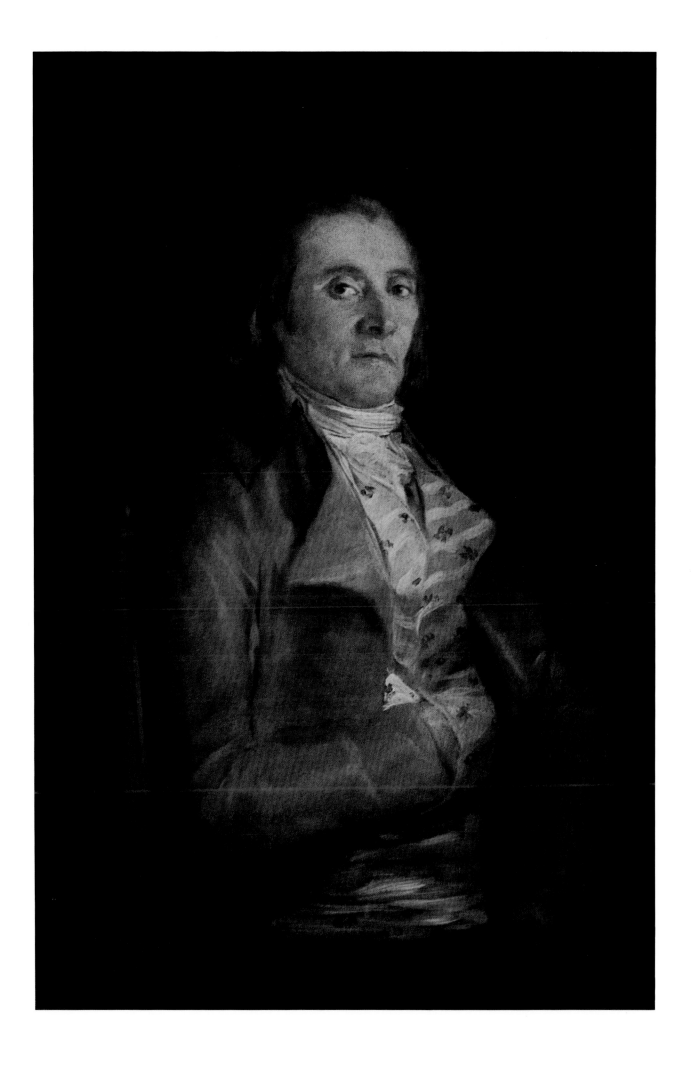

THE MIRACLE OF SAINT ANTHONY OF PADUA (portion)

Fresco

San Antonio de la Florida, Madrid

These frescoes for the Hermitage of San Antonio present, in the central cupola, *The Miracle of Saint Anthony of Padua*, and, in the apse, *The Adoration of the Trinity by Angels*. Goya's style, simultaneously opulent and dramatic, is here in its central and culminating phase. In the two extant sketches for these decorations (Collection Marquis of Santa Cruz) one may notice a break-up of the unit into groups having a certain autonomy, reminiscent of the Aula Dei paintings. Secondary scenes are organized within the principal scheme.

The technique is direct and spontaneous. The composition in the cupola almost rigorously denies the hemispherical space by reducing the cloud effects and summarily sketching in the details of the pictorial area of the upper dome. The principal part, with St. Anthony and the resuscitated man, is found in the cupola's north section. To the right, there follows a spectacular array of people, in which the entire Goyesque world is found. The frieze-like arrangement of nearly fifty figures, animated by a variety of types and attitudes, appears behind an iron railing. They are projected against a space rendered with all the bold technical resources inherited from the Baroque—although Goya's interest is greater in the human than in the spectacular elements. Truly wonderful contrasts of character and sentiment are achieved by the colors and the luminosity.

The dominant effect of this work results from Goya's disregard for traditional techniques. There is a profound unity in this two-sided rebellion against established canons of beauty. Added to the artist's disdain for finely finished forms and continuous modeling is his aversion to the usual characterization of saints. Like Velázquez, Goya has also rendered with extraordinary beauty the many subhuman beings represented in the cupola decorations. The sublime and the diabolic carry Goya's feeling for the pathetic to its culmination, as may be seen in the blind beggar garbed in yellow, and in the almost simian appearance of some figures. Others, particularly the beautiful *majas*, seem ostentatiously indifferent to the miracle before them.

In the entire work, including its most pleasant passages, may be seen a certain violence of feature. The foreshortenings of all poses are resolved with masterful simplification. Brush strokes here intervene, leaving forms dissolved to a considerable extent, and rendering a suggestion of movement and luminous reflections.

The angels in the arches, spandrels, and apsidal dome contrast with the dome paintings; they are executed in predominantly pearly and golden hues, with blends of grayed-reds, blues, ochers, and violets. However, the technique is identical with that of the dome frescoes, and the forms of the angels possess both a bland imprecision and a rotund strength.

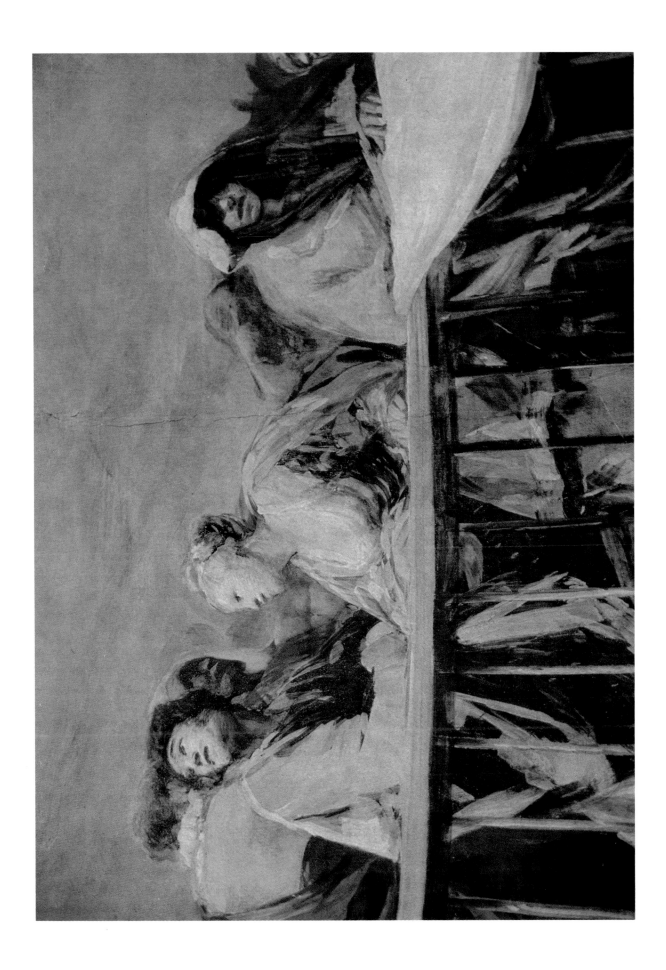

Painted c. 1800

THE MAJA CLOTHED

Oil on canvas, 37³/₈ × 74³/₄"
The Prado Museum, Madrid

The Maja Clothed is one of the works most difficult to place in Goya's chronology, though it must have been executed a little before 1800. Together with *The Maja Nude*, its companion piece, *The Maja Clothed* is one of Goya's most celebrated paintings. Both have become well known, not only as a result of their subject matter, but by virtue of their masterful quality as well. The elongated format causes the pictorial setting to surround the feminine figure quite closely, contributing in part to the character of the work. The opaque background, an orange-tinted ocher wall, harmonizes with the burnt sienna hue of the *maja's* short jacket and with the rose-colored sash binding her waist. A very close point of view monumentalizes the feminine body. Her turgid, well-modeled form—which follows as closely as possible the structure of *The Maja Nude*—is intimately outlined by her closely fitted dress. The white of the dress reflects rich and iridescent tones that modify local colors by blending them with color and light in a manner akin to that later developed by Delacroix. The large pillows and white bed coverlet are affected to an even greater degree by tints suggestive of shadows, by luminous reflections, and by the transparency of fabrics modified in their tones according to density, folds, and proximity to other color elements.

The technique is at once refined and summary, delicate and tumultuous. The spectator is left more impressed with the splendor of form and light than with the value of each formal part in itself. Different qualities are strongly contrasted. Thus, the short, frog- and braid-trimmed black jacket is especially visible on the *maja's* arms. And thus her arms acquire a greater roundness than the rest of her body, which is enveloped in less constricting, dense fabrics. There is a marked *sfumato* quality in her face, of an origin seemingly more emotive than strictly luminous. Within this *sfumato*, linear factors are suggested rather than effectively delineated. Goya's impasto is richly though not excessively worked, and is thickest in the white of the *maja's* dress. Very characteristic of Goya are the qualities of forms, highlights, and shadows amassed at the right of the *maja's* seductive head near the edge of the divan and the uppermost pillow.

78

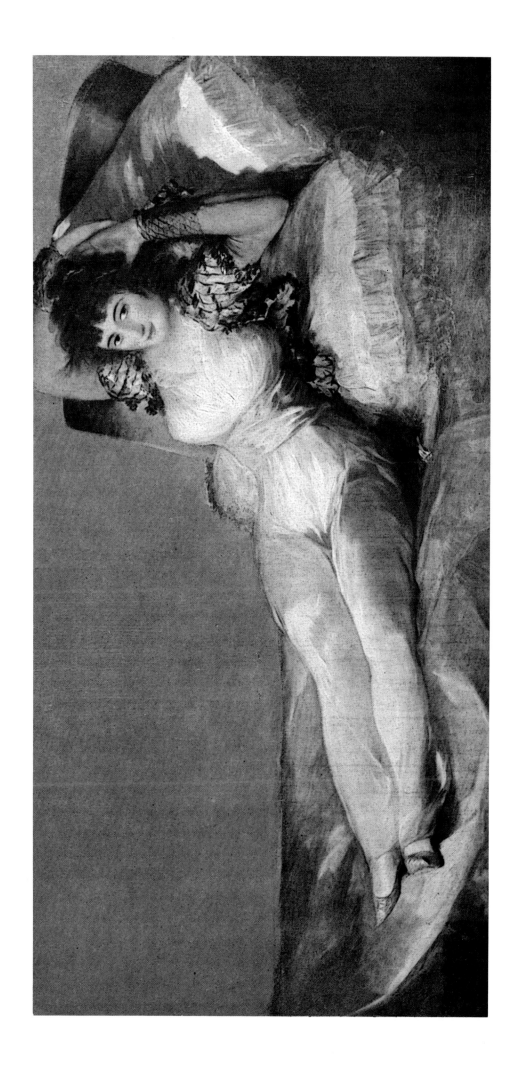

Painted c. 1800

THE MAJA NUDE

Oil on canvas, 37³/₈ × 74³/₄"
The Prado Museum, Madrid

The rarity of nudes in Spanish painting is well known. Together with Velázquez's *Venus and Cupid*, this Goya canvas is a masterpiece of this genre. In a very general comparison, there might be noted the idealized character of Velázquez's *Venus* as opposed to the sensualism of Goya's *Maja*. The Velázquez painting—which could not be regarded a tactile work according to the dictates of Wölfflin—appears much less profoundly pictorial when compared with the Goya creation. In Goya's famous nude, a woman is shown indolently cast upon large pillows covering a couch. The forms of these pillows provide a rhythm closely related to that of the figure's beautiful body curves, contributing decidedly to the deeply coherent feeling of this masterful work. Unlike the Baroque master, Goya only sparingly utilizes contrasts of light and shade. The way in which such contrasts are used, however, suffices to render firm and compact modeling.

Goya knew how to evoke the sensations of full volumes, corporeality, and weight in an unsurpassed fashion. Though painted in his period of descriptive formalism and abundant human forms, *The Maja Nude* does not degenerate into coarse reality. Rather, Goya's refinement of means provides beautiful qualities of pearly flesh tones and an almost ornamental boldness of outlines. The body seems to be completely illuminated by a very even light that is neither intense nor weak, somewhat losing its quiet strength only beyond the *maja's* body in the sheets, pillows, and background wall. The light source is seemingly in the spectator's plane, from slightly below. In technique, there is a careful synthesis of naturalism and impressionistic intuition, strongest in the feeling of luminosity. The nude *maja's* luxurious and serene attitude, her frank glance directed toward the viewer and expressing total indifference to her nudity, and the composition as a whole motivate one of the most justly famous images in all Spanish painting.

The Maja Nude and *The Maja Clothed* seem to have formed a pair of paintings that could be alternately hung at will. They belonged to Godoy and possibly were a part of the decorations of his Madrid palace.

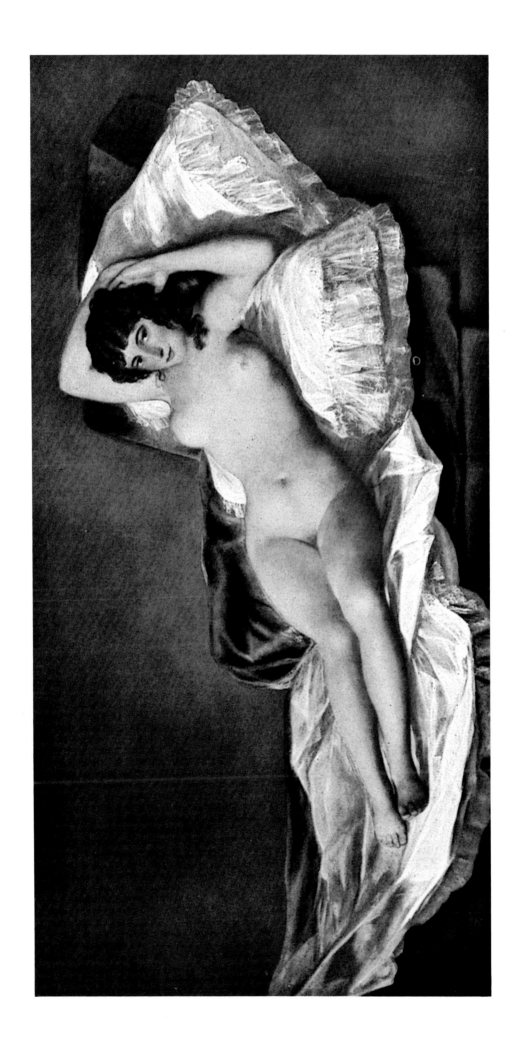

Painted 1800

THE FAMILY OF CHARLES IV

Oil on canvas, 110¹/₄ × 132¹/₄″
The Prado Museum, Madrid

In this large canvas painted during the spring of 1800, the entire family of the monarch are represented in an arrangement within a shallow space. From left to right are seen: Don Carlos María Isidro, garbed in red; Goya, painting and placed half in shadow so as not to confuse his image with the royal family; the Prince, later Ferdinand VII, in blue; Doña María Josefa, in white; the Prince's intended princess, not yet decided upon at the time and hence with her face turned toward the background; Doña María Isabel, in white and green; Queen María Luisa, in white and yellow; Don Francisco de Paula, in red; King Charles IV, in chestnut brown; Don Antonio Pascual, whose face is seen with only a fraction of his figure, in blue; Doña Carlota Joaquina (?), of whose figure still less is visible; Don Luis, Prince of Parma, in orange; his wife, Doña María Luisa, in white and gold, holding their son, Carlos Luis, in her arms.

Goya arranged the composition of the royal models to form two compact groups at the right and left, leaving a more ample space in the center where the monarchs appear with their youngest son. The figures are separated in depth by a very slight distance. Only two or three planes, barely distinguishable, are established. A wall on which hang two large, unidentified pictures creates the background. With a flexible grouping, Goya obtained a pleasing and natural composition that avoided the likely danger of a frieze-like monotony resulting from placing a row of models within a horizontal extension of little depth. The source of light is apparently in front of the group and at the left, almost in the traditional forty-five degree angle. Shadows are thus projected to the right rear, the upper parts of the models and some entire figures remaining well illuminated, particularly those of the monarchs and their younger children, whose white clothing enhances the light.

Most noteworthy in this canvas is not only the successfully rendered union of all the figures, but the extraordinary harmony of color and parts. Here at their finest are all the suggestions of brilliance, weight, and consistency that make this group portrait an incomparable spectacle. Warm shades predominate, not stridently, but almost deprived of intensity. The yellowish-white light gives tonality to ocher shadows and chestnut hues as well as to the most evident oranges and yellows of the outfits.

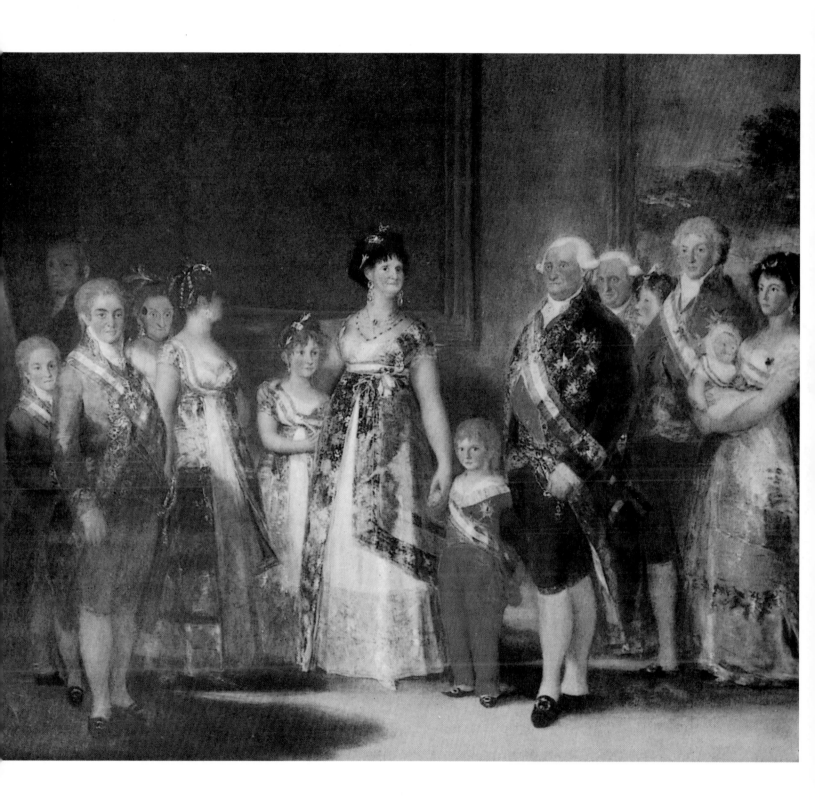

Painted 1800

THE FAMILY OF CHARLES IV

(detail: Doña María Isabel and Queen María Luisa)

The Prado Museum, Madrid

The center of the painting of *The Family of Charles IV* is not the King, for all his medals and noble stance, but Queen María Luisa with her young children, one at each side.

No problems in representing the royal persons existed for Goya, who frequented the royal family and who had already portrayed some of its members several times.. Moreover, careful preparation by means of separate studio sketches of each sitter permitted him to attend primarily to problems of organization, on undertaking the general composition. If the royal models manifest a bourgeois attitude— almost approximating the vulgar, in the monarchs themselves—it is because they actually possessed such qualities; Goya was inured against avoiding the direct expression of this attitude and rendered it without modification. Several of the younger members of the family, such as the Infante Don Carlos María Isidro or the rulers' younger children, Doña María Isabel and Don Francisco de Paula, placed next to María Luisa, offer an air of spirituality in contrast to the mien of the other figures. In this painting, Goya does not demonstrate an interest in accentuating specific faults or psychological characteristics. Rather, he offers an impassioned presentation of plastic values.

Perhaps because Goya had conscientiously planned the preparatory work, he could dedicate himself completely to giving life to this composition with the same fervor—though somewhat more contained—that would later animate the patriotic furor of *The Second of May*. As in the latter, Goya succeeds in *The Family of Charles IV* in masterfully capturing the feeling of the epoch—that moment of transition between the final splendor of the rococo world and the advance toward, not romanticism, but, indeed, later nineteenth-century realism. Nevertheless, a classic grandiosity, imbued with dissoluteness and including sarcasm, still predominates in this work. Goya's own inner conflict, as a figure at court and yet a common man, resigned to gratitude for royal favor yet basically insurgent, becomes transparently clear in this composition as in few others by the artist.

The harmony of colors is extraordinary. Goya has attained in this painting that unique effect of great mastery that comes about from a perfect balance between the life of each color and the harmony of tones, simultaneously both coloristic and austere. The predominant chestnut browns and blended reds, in contrast with clear whites and yellows, are in their own turn dominated by almost imperceptible transitions of tones. At once refined and bold, this picture epitomizes Goya as a painter of compositions and as a portraitist. In this work, the idea of the total painting is clearly predominant over the passion of the artist as portraitist.

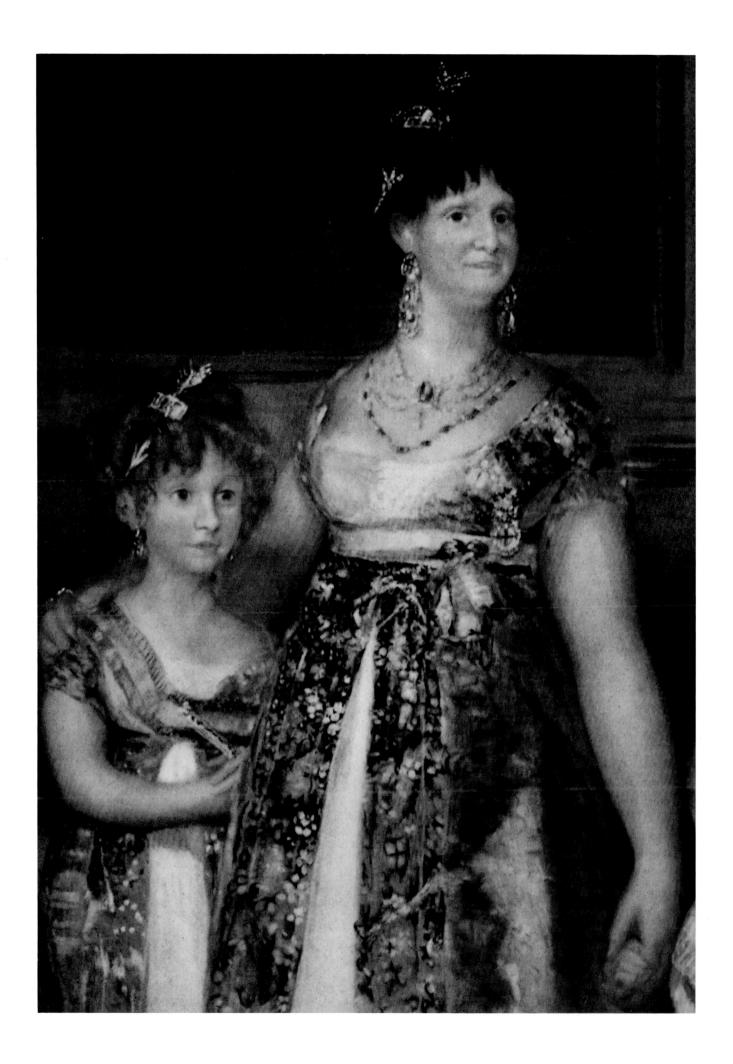

Painted 1800

PORTRAIT OF THE COUNTESS OF CHINCHÓN

Oil on canvas, 83^1/$_8$ × 54^3/$_4$"

Collection Duke of Sueca, Madrid

In this masterful portrait painted by Goya in 1800, it is difficult to say which is more admirable, its plastic values or the sensitive interpretation of the sitter. Goya had earlier portrayed the countess as a child in the house of her father, the Infante Don Luis de Borbón. At the time of the present portrait, however, she was the wife of the powerful minister, Manuel Godoy, Prince of La Paz. Her life was one surrounded by intrigue; her unhappy existence is reflected in her fine and delicate face. The neutral, dark background is of a simplicity that contrasts with the figure. Shadows press evenly at the right, penetrating the form somewhat and contributing to an effective and suave modeling. As is frequently the case in Goya's portraits, the area of greatest illumination is found before and slightly below the figure, thus appearing strongest in the reflections on the fabric covering the knees. Shadows also intervene at the left, although with less intensity. Therefore a detachment from the background is complemented by a clear separation of right and left, causing the figure to be seen somewhat obliquely in relief.

An extraordinary refinement, in both the summary and the specific, renders every detail of the image in exquisite perfection. Great liveliness and a faithful expression fashion the countess' face. There is a supreme delicacy in the modeling of the neck and the décolletage, as well as in that of the arms and hands. The dress fabrics take on a life of their own as they fall toward the wide folds of the skirt. At the right, brightly formed creases coming out of the shadows of the deeply modeled skirt are exceptionally skillful and expressive. The suggestion of animation felt in the contours of the figure must also be noted. This animation is indicated particularly by the rhythm at the left, from the ribbons and feathers adorning the young woman's head to the decorative border edging her skirt.

PORTRAIT OF THE COUNT
OF FERNÁN NÚÑEZ

Oil on canvas

Collection Duke of Fernán Núñez, Madrid

No marked change in Goya's technique is indicated in this signed and dated portrait of 1803. Nevertheless, a certain aesthetic modification is demonstrated in several effects and in the manner of surrounding the model. Accentuated in this portrait is an interest in clarity and vigor of linear rhythm, which had earlier appeared more subordinate to the pictorial impression. The impudently posed attitude of the subject, made evident in the contours of the figure, provokes the noted linear character of appearance. The lighting further favors clarity of design, permitting the artist to give value to each area, and to accent autonomously the features of the costume.

The large two-pointed hat, the dark-blue, velvet-faced cape strongly contrasting with the white-garbed leg visible to hip level, the position of the feet themselves, and the proud demeanor of the count show the figure to have been composed according to a concept of linear trajectories. These latter are as interesting as the surfaces and the spots of color. Also, the figure, unlike those in other Goya portraits, is not submitted to the action of intense shadows coming from the background, but stands out brightly against a landscape setting. While this landscape indeed shows one of those stormy Goyesque clouded skies, yet it offers a strong value contrast with the figure, centered in the pictorial area that it almost completely fills by its height.

As always, the human element is predominant. However, there is a more evident interest in the figure's surroundings than had appeared earlier. A vigorous degree of finish, with a satisfying tactile quality, brings a particular naturalism to the portrait. Play of light, which dissolves the smaller forms and the qualities of material in other Goya works, does not make its presence felt here. Thus the entire figure has a great solidity. The face, and the black-tinged flesh tones of the hands holding the cape, are magnificent. Equally so is the gesture of haughtiness and curiosity with which the count looks to the right, with raised eyebrows as full as his long side whiskers. The knowing mixtures of black, blue, gray, and yellow are very characteristic of Goya's palette. The whites of the tie, the shirt frill, and the right leg, together with the predominant black, enhance the blendings of color. In summary, this portrait is another one of those Goyesque creations in which the painter successfully captured a basic feeling for the Hispanic tradition, as much in the type of the model as in the form and color.

Painted 1810

ALLEGORY OF THE CITY OF MADRID

Oil on canvas, 102⁵/₈ × 76³/₄"

City Hall, Madrid

In this famous canvas, Goya returns to allegorical subject matter, rare since examples of his earlier period. Here, the illustrative character is accentuated; the composition resembles an eighteenth-century book frontispiece engraved in the Renaissance tradition of allegory. Spirits of Fame, represented as androgynous angels, fly through the upper area. At the right, two winged spirits exhibit an oval medallion framed with palm leaves, in which originally a portrait of Joseph Bonaparte appeared. However, the portrait and dedication were altered in accordance with the changing political atmosphere: the present inscription commemorates the beginning of the fight against the Napoleonic occupation.

At the left is the female personification of Madrid, with the Madrid coat of arms and a greyhound completing the composition. The personification is emphasized by her size and frontal position, her bright dress, and the clear representation of her form; but she has a serene and ecstatic attitude, which contrasts with the movement of the other figures and commands the spectator's eye. This subject obviously implied a special aesthetic. Though Goya's technique is wholly contemporary, the composition of this work reverts to the spirit of the late Baroque; Goya has sought within his own development for the elements necessary to execute the work. Vigorous chiaroscuro makes the figures stand out clearly in order of their importance. The drawing is rich in varied rhythms, and the linear factor has abundant interest by virtue of its continuous undulation. The range of color and of value contrasts is well executed; the parts are all successful in every detail.

One might object to the theme of this work because it bears, as already pointed out, so close a relationship to prints of a similar subject. The painter might also be criticized for having rendered space with excessive simplicity, disposing all the figures in a single plane parallel to the surface; by omitting oblique lines of escape, he prevents the viewer's glance from penetrating into the distance at any point. His representation of form, on the other hand, has a singular fullness, bringing out the delicacy of flesh tones and smooth freedom of the fabrics.

Demonstrating here another facet of his extensive temperament, in opposition to his preference for the dramatic and the grotesque, Goya has, in the countless details of execution, endowed the canvas with a sensitive lyricism.

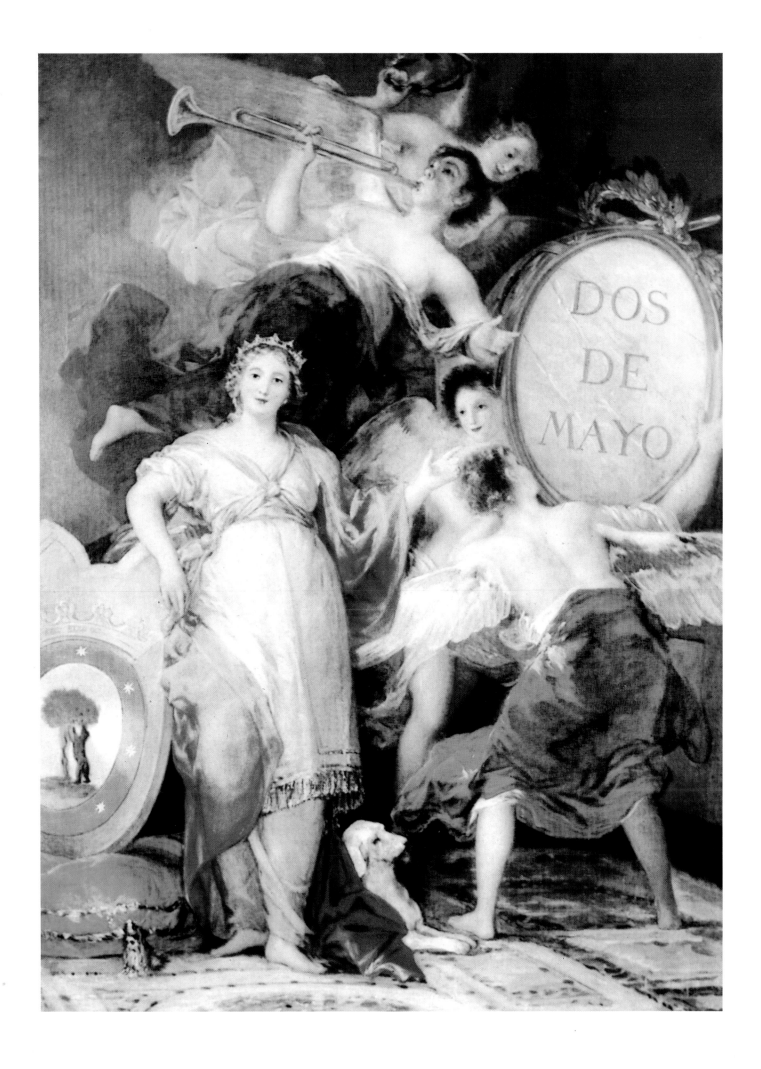

Painted c. 1811

PORTRAIT OF JUAN ANTONIO LLORENTE (detail)

Oil on canvas, 73³/₄ × 44⁷/₈″
Museu de Arte, São Paulo, Brazil

This ecclesiastic, of only slight orthodoxy, presented Goya with the subject for one of his most intense portraits. Painted in 1811–12, the figure is presented full length without any surrounding elements. The portrait seems activated by strong blobs of color, primarily those of the sitter's red mantle and the decoration suspended from a ribbon upon his chest. The face has an enormous expressiveness, with its skeptical smile, unkempt locks of hair at the temples, audacious glance, and the solid structure of the forehead, cheekbones, and jaw. But most outstanding in this portrait, as always in Goya's work, is the quality of the painting—its color modulations that model light and give effectiveness to flesh tones and fabrics, its precise brush strokes that exactly place each touch of color.

The manner of capturing the sitter's personality in his glance is miraculous; the elements that permit the profound grasp of contact may be uncovered almost without analysis. It is clear that Goya succeeds in these effects by virtue of the relationship existing among the formal elements of the face. The smile slightly dilating the mouth, the shape of the eyebrows, and the tones of the complexion collaborate in a scarcely perceptible manner to influence the expression of the eyes, thus creating a personality that is amazing to the spectator. In a portrait such as this, one may observe to what extent Goya disdained the anecdotal and conventional aspects of portraiture in favor of the essential human factor and the imperishable reflection of its truth.

Painted c. 1810

A KNIFE GRINDER

Oil on canvas, 25⁵/₈ × 19⁵/₈″
Museum of Fine Arts, Budapest

With regard to this picture, it is interesting to note the attention Goya gave to the theme of humble occupations throughout his career. In this respect, as in others, Goya is the precursor of nineteenth-century realists and impressionists. He executed many drawings, prints, and paintings in which he created groups or single figures having this theme, evidently cultivated in accordance with his personal taste. Within its context, Goya chanced a new approach to that popular background of which he himself had been a part prior to his becoming painter to the king, and friend, or at least habitué, of nobles and the court. However, Goya, particularly in his late works, never neglected to instill in the workers he represented a certain restlessness, perhaps only barely perceptible, but evident nevertheless. Thus this work does not offer an amiable and indifferent appearance, as had the earlier tapestry designs, but is infused, rather, with a dramatic quality. This could derive partly from a projection of the painter's own temperament, but it is perhaps also to some degree the result of Goya's feeling an increased distance between himself and that social class from which he had become separated. It was precisely this feeling that was reflected in Goya's placing of the distinguishing *"de"* between his baptismal name and his surnames.

The sense of drama in the Budapest *Knife Grinder* is enhanced by an absence of background elements. Goya has captured the grinder at his task, inclined over his grindstone; his head has been raised to regard the artist with an expression at once trusting and troubled. The quality and reflections of hues in the large space behind the figure seem a rudimentary anticipation of the expansive background seen in the Prado Museum's *Head of a Dog*; in both works, this factor contributes substantially to the total effectiveness of the representation. The small cart on which the grindstone is mounted is frugally painted. Goya leaves it in a shadowy dusk, concentrating attention instead on the bust of the grinder, precisely as is done in his commissioned portraits of important persons. In this painting, something may be seen of the mood soon to burst forth in the "black paintings" that Goya created for his own house and in accordance with his own personal and strange taste.

94

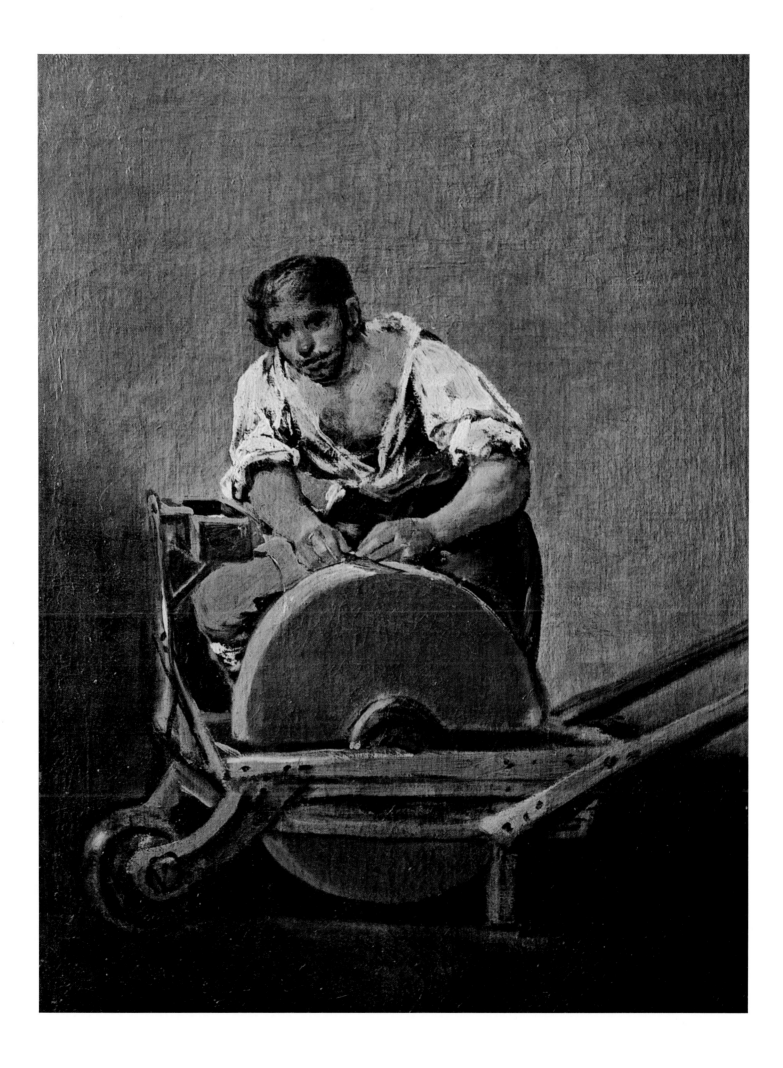

Painted c. 1810

THE WATER SELLER

Oil on canvas, 22 × 16³/₈"

Collection Norton Simon, Los Angeles

This version of *The Water Seller* is a replica of another, identical in theme and composition, in the Budapest Museum of Fine Arts. Thus it is in itself a companion to the preceding *Knife Grinder*. Though what is essentially pictorial in this painting, or even its technique, may cause it to find favor, its primary attraction lies in the subject. In this common Spanish woman of lowly occupation, Goya has captured with directness and vibrancy the regal dignity that frequently appears in superior persons of whatever social class. Goya confirms this impression by highlighting the model's somewhat disheveled hair and fixed, slightly challenging stance against the radiance of the background, and, further, by straightforward color harmonies based upon complementary hues. The pearly flesh tones, the vivid yellow of the blouse, and the dark shade of the skirt effectively coalesce with the clear blue of the sky, each hue mutually stimulating another. The woman emerges as an enchanting apparition, unlike those many Goyesque visions in which the painter found release during his hours of solitude. This canvas is of a somewhat later period, when the artist had already undergone many of his torments and vicissitudes. Extremely direct and natural, this figure evokes the later *Milkmaid of Bordeaux*, yielding an imperishable impression of Goya's forthright, captivating freshness and the flexibility of his infallible, synthesizing technique, comparable only to that of Velázquez. Strokes that are artful, though not clearly defined, give a sense of movement to the left arm, its hand firmly grasping a basket of drinking glasses.

96

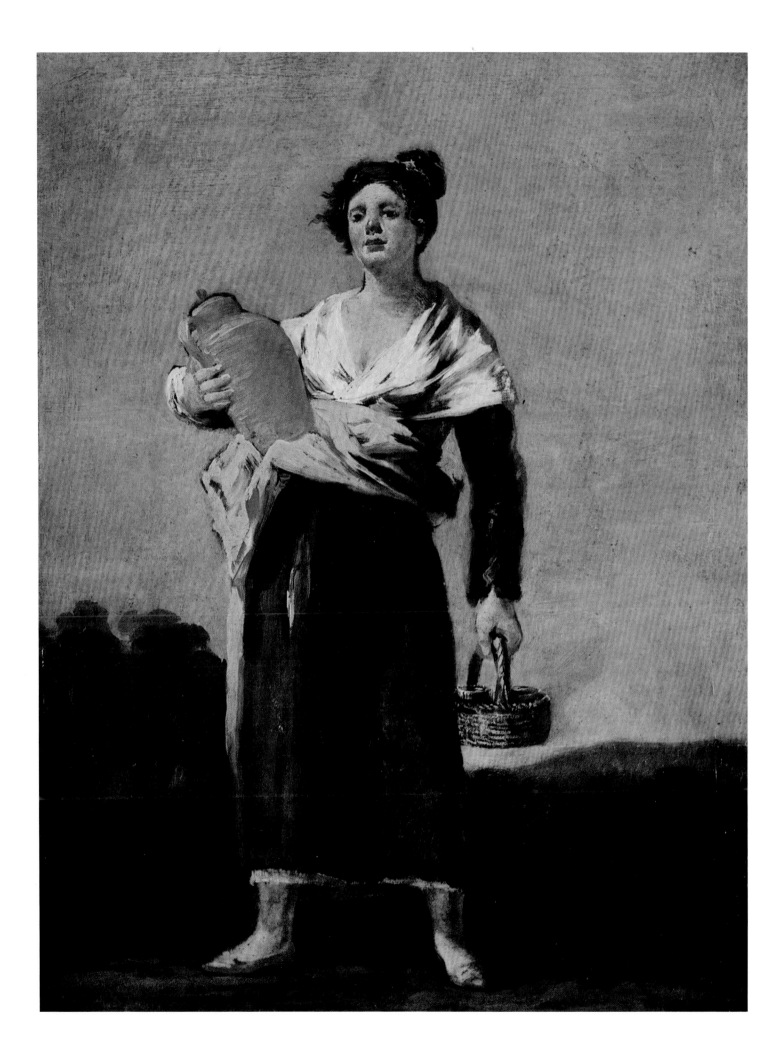

Painted c. 1811

THE COLOSSUS

Oil on canvas, 45⁵/₈ × 39¹/₂″
The Prado Museum, Madrid

This painting is doubtlessly the one mentioned in the inventory of Goya's possessions drawn up at the death of his wife in 1812. The corpulent, bestial-featured Colossus, looming amidst a background of clouds and mists and terrorizing the encamped multitude, is certainly an allegory of the great catastrophe of war. Inasmuch as the Napoleonic occupation began in 1808, the approximate dates are known in which this extraordinary painting was executed. As in other panoramic views with large numbers of people, Goya here divides the mass, structuring it in a series of groups—or better, of tiers—formed by men, women, horses, and carts. All flee, disbanded, their mobility contrasting with the strange quietude of the Colossus. Such images as the Colossus were not usual in painting, but they existed in illustrative prints and allegories where fantasy—derived from literature—had a more propitious field in which to evolve. Goya's daring, like that of the earlier Spanish Baroque artist, Valdés Leal, consisted of translating the spirit of an illustrative art into the pictorial technique. That Goya could successfully achieve this translation was due precisely to the nature of his art, an art of absolute pictorialism capable of justifying any degree of boldness and of transforming such boldness into motifs of authentic plastic qualities.

Apropos of such works as *The Colossus* or the "black paintings," his grasp of the immediate is surprising. Subsequent contemplation, however, leads to a consideration of the color values, tones, and technique; the theme becomes almost a matter of indifference in comparison with our interest in its realization. In *The Colossus*, his pictorial brevity is carried to an extreme; it is nevertheless able to present and suggest the figures of the composition. What at first glance appear to be convincing forms of animals and humans are seen, on study, to be mere vestiges of paint. These rough strokes nevertheless occasionally differentiate these forms from their surroundings by providing a qualitative contour. Long, continuous brush strokes integrate the distinct parts into larger units, suggesting the contiguous elements and rhythms that constitute the final effect.

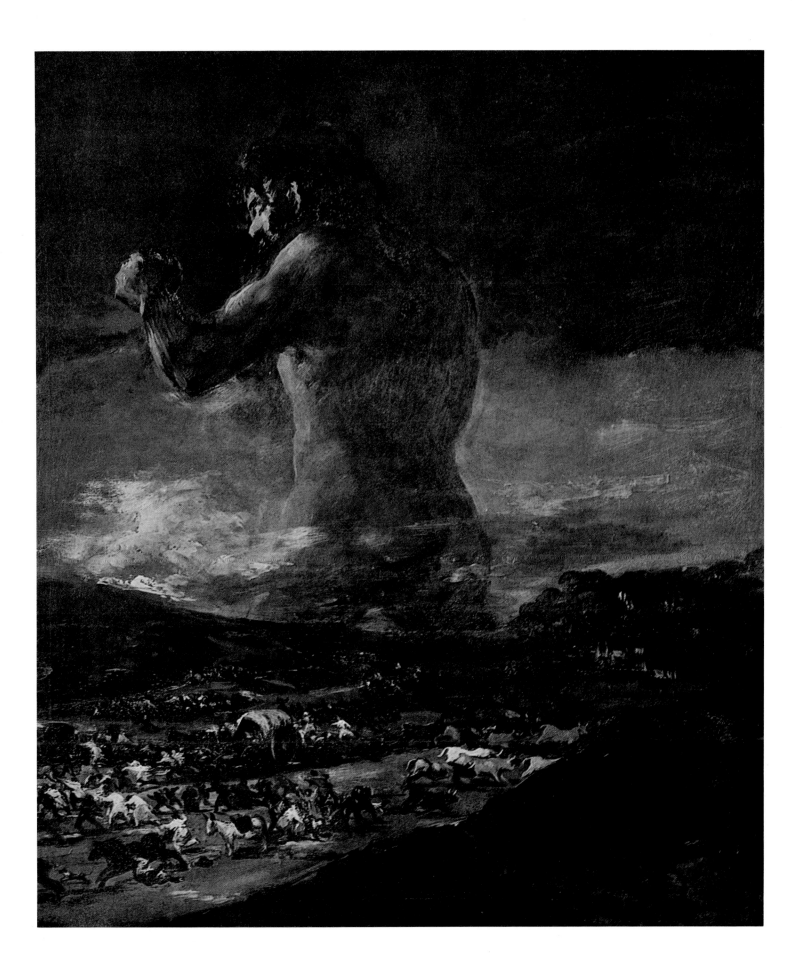

Painted c. 1810

A CITY ON A ROCK

Oil on canvas, 33 × 41"

The Metropolitan Museum of Art, New York

(Bequest of Mrs. H. O. Havemeyer, 1929. The H. O. Havemeyer Collection)

So surprising in both subject and technique, this canvas recalls the statement of
Goya's grandson that an entire group of the master's paintings "had been executed
using fine reeds, open at the ends, rather than brushes." With a palette knife thus
formed, and employing dense and fluid pigment, Goya was able to achieve
irregular, clotted strokes impossible to achieve with the metal blade of the ordi-
nary spatula, or even less with the brush. These works must have been painted
during the years from 1810 to 1820. Goya's attention to this technique reveals
his continuously probing sense of experimentation, as well as his attraction for
dramatic, expressionist effects. At first using the reed alone in certain details or
in areas worked with the brush, Goya in certain instances later succeeded in
realizing paintings almost exclusively with the reed procedure. The *City on a Rock*
was prepared with the brush, and subsequently worked with the reed. Thus its
rare effects have been united to its theme, derived from the imagination and related
to *The Proverbs* series of prints by the master. Three flying monsters appear in the
upper part of the composition. The mountain, which appears to be an enormous
rock, seems encircled at its base by large bonfires, amidst which may be distinguished
human silhouettes. The reed palette knife has been employed with maximum
force in the lower right section. Here, in the chromatic intensity of blues, whites,
and very vivid reds, as in the almost brutally simplified strokes, is seen one of the
moments of greatest grandeur in Goya's work. Goya could also reflect extremely
well with his palette knife the textural quality of the rock and of the buildings
at its summit, lost in a phantasmagorial sky. Organization of tones in the central
area of the mountain, and at the lower left, includes vigorous zones of shadow
treated with an incredible rhythmic force.

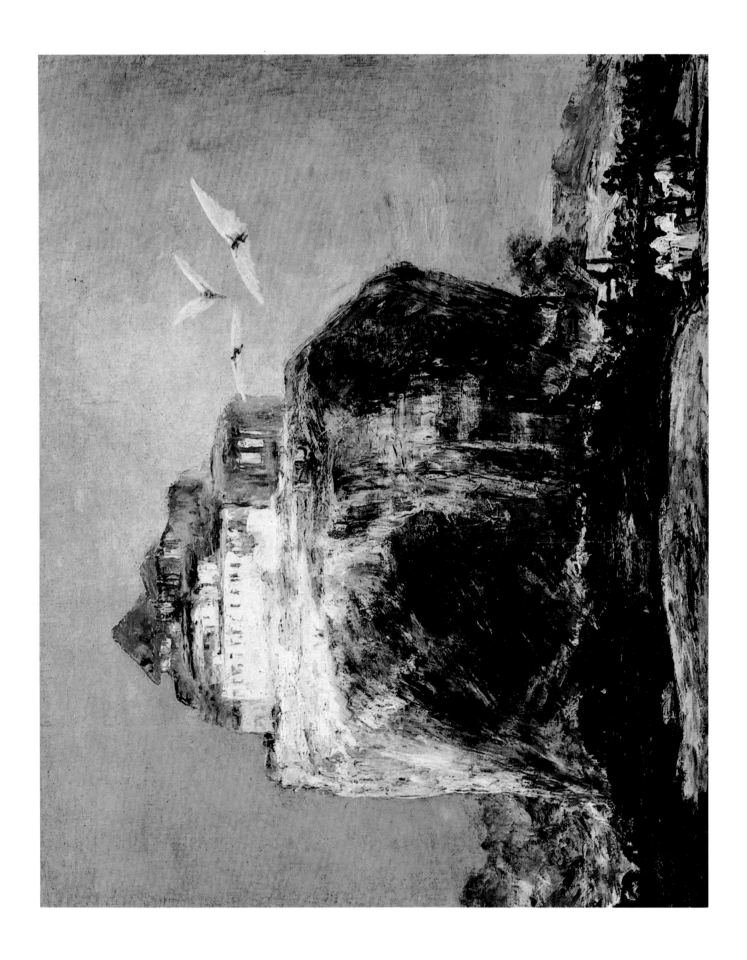

Painted c. 1811

MAJAS ON A BALCONY

Oil on canvas, 76³/₄ × 49¹/₂″

The Metropolitan Museum of Art, New York

(Bequest of Mrs. H. O. Havemeyer, 1929. The H. O. Havemeyer Collection)

This is one of Goya's most famous paintings, perhaps partly as a result of its subject. Two young women are seen seated behind the metal railing of a balcony, mantillas covering their heads. The heads are placed very close together and the glances forward indicate contemplation of something that stimulates their interest and curiosity. Behind them appear two *majos* ("gallants") enveloped in capes, with large bicorn hats on their heads. In a theatrical manner, Goya counterpoises the spontaneous movement of the women against that of the muffled, shadowy figures of the men. The two male forms are rendered with more summary strokes, though the figures are well detached from the background. Drawing specifies the forms to a certain extent, and pictorial qualities alternate between rigorous imitation of the material and a simple allusion in which the autonomy of the brush stroke is maintained. Thus are all the adornments of the *majas'* garments formed—with touches of light rather than with strict representation of details. In the flesh areas, material quality acquires a greater identification, and the drawing a firmer structure, though—as is usual with Goya—linear values are sacrificed in favor of surfaces and volumes, modeled in relief rather than in flat planes. The male figures seem simply sketched, particularly the *majo* at the right, though the weight of his body is felt, nonetheless, under the folds of his dark cape.

The mixture of frivolity and drama that characterizes many of Goya's works here appears perfectly captured. This painting was included in the inventory drawn up at the death of Goya's wife in 1812. It is a good example of the transformation that Goya, in his mature period, wrought upon themes and figures he had represented earlier in the tapestry cartoons. Monumentality and simplification of form have superseded narrative sentiment, and the surroundings have been reduced to a minimum.

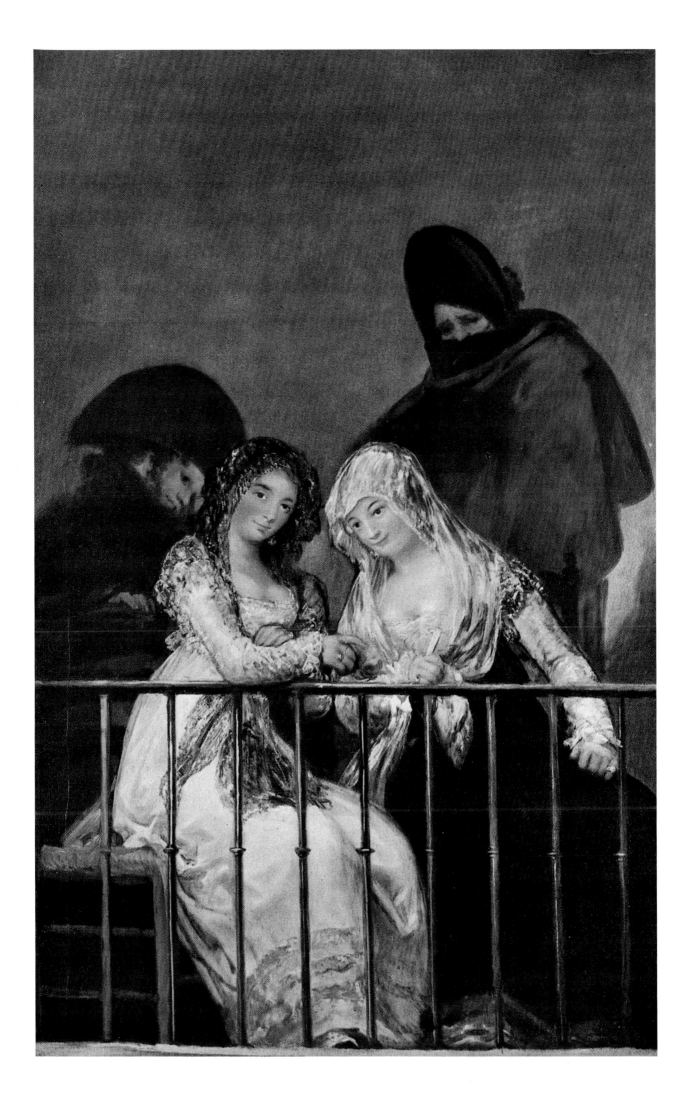

Painted c. 1811

THE LOVE LETTER

Oil on canvas, 71¹/₄ × 48″
Museum of Art, Lille, France

The well-known pair, beauty and the temptress, have been treated by Goya in this work. However, the temptress is not interpreted with the harsh features of an elderly Celestina, but rather with those of a young woman. It may be observed that, as in the painting of Goya's preceding period showing a girl and her evil female adviser on a balcony, shadow is also employed here in a sense that seems to exceed the normal effects of light, plainly endowing the woman in question with a negative and malign character. In *The Love Letter*, both women are centered in the pictorial area, which apparently represents the outskirts of a city. Behind them appear groups of kneeling washerwomen. In the foreground, a small lap dog jumps upward on the young woman's skirt, seeking, in vain, her attention, that remains focused upon the love letter her companion has delivered to her.

This second figure, set slightly to the rear of the first, opens an umbrella to protect them from the sun's rays. In spite of the brilliance of the sunlight, a number of clouds, and those vague colors and lights frequent in Goya's painting, appear in the sky. Notable is the resplendent whiteness reflected by the fabrics put out to dry, which serve as a background to the scene. Nevertheless, it is important to recall that Goya, despite emphasizing light and shade, does not fall into the banality of converting his painting into a play of light effects, as some of his nineteenth- or early twentieth-century followers would. With Goya's undeniable power, luminous effects are relegated to secondary interest.

Form possesses the incisiveness of an engraving in this canvas. This distinction is attained by means of intense value contrasts, the quality of the pictorial effect, and perfect spatial construction. The latter gives value to each extremity, from the woman's foot in the foreground to the furthest background details. The shadow projected upon the holder of the umbrella does not reach the principal figure. Thus an essential contrast is created which, as has been said earlier, is as much expressive of drama as it is an effect of light.

The variety of pictorial qualities Goya achieved in his figures should also be noted. Some forms are roughly sketched; in others, Goya has minimized the feeling for volume, using an almost flat hue—very sparing in pigment and of a polished texture—approaching the technique of some works by Velázquez. The woman in the foreground plane, however, is rendered with very intense impasto, particularly in the shawl that wraps her head and neck. Yet, simultaneously, a precise and firm drawing endows the figure with a rotund volume.

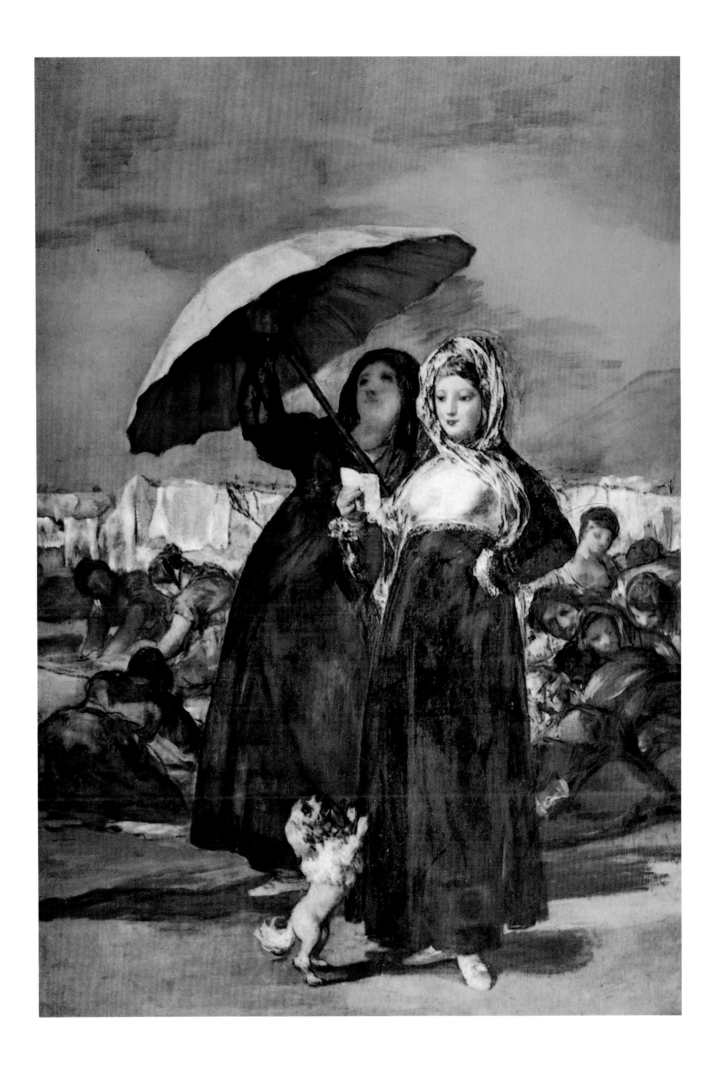

Painted 1814

THE SECOND OF MAY, 1808, AT MADRID

Oil on canvas, 105 × 136¹/₈″

The Prado Museum, Madrid

This famous Goya canvas presents the spontaneous uprising of Madrid's population against the mamelukes of the Napoleonic cavalry. Two preparatory sketches for the composition are extant. One of them varies to a greater degree from the final work in several respects and, therefore, is probably the earlier of the two; the arrangement of the scene differs, as does the impetuous and spontaneous technique of dense impasto and violently contrasting masses. A certain confusion of forms is also noticeable. The second sketch is closer in architectural background to the large Prado painting. A superior arrangement of plastic and dramatic effects is also to be observed.

In the final work, form has been clarified to an even greater degree. A multitude of figures may be seen in detail, as are the buildings in the background. Armed only with poniards and knives, the desperate Spaniards throw themselves against the mamelukes. The scene is tumultuous, full of action, color, and movement. There is nothing in this painting that shows Goya's shaping of form. Action is completely the protagonist; the central characters and foreground plane scarcely predominate. Anonymous elements acquire special importance though each one is knitted into the totality of the work by violent and continuous rhythms. There is a certain softness of tactile qualities present, and a very slight contrast of light and shade between the planes.

The motley group of combatants forms a brilliantly colored mass, with red and yellowish-ocher harmonies balanced by greenish-grays and dark maroon. Men fallen to the ground, bloodstains, uniforms and civilian clothing, horses, and weapons are not represented separately but as integral parts within the whole. Perspective and sense of volume, while not absent, have been partially neutralized so as to give greater intensity to the action. A kind of muted flexibility is vividly expressed in the pressing multitudes acting inside a limited space, caged between the buildings. As a result of these features, this Goya canvas becomes an exponent of the romantic aesthetic that it directly predates.

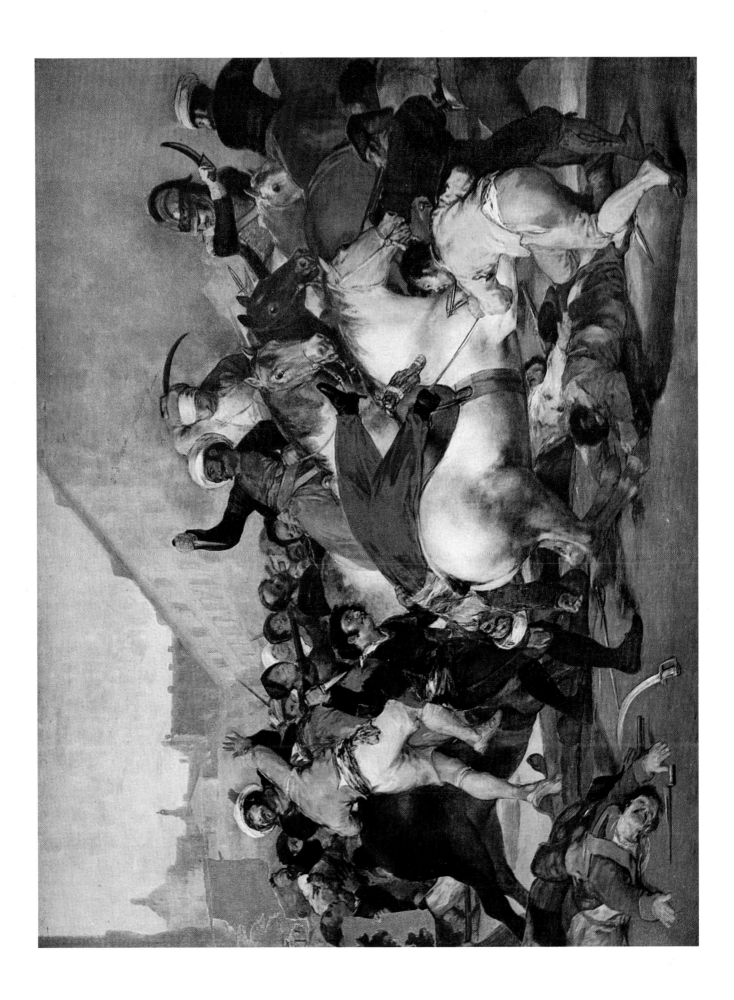

Painted 1814

THE THIRD OF MAY, 1808, AT MADRID: THE SHOOTINGS ON PRINCIPE PÍO MOUNTAIN

Oil on canvas, 104³/₄ × 135⁷/₈″

The Prado Museum, Madrid

This companion piece to the preceding scene of the fight against the mamelukes was painted by Goya as a record of the nocturnal executions of Spanish patriots by Napoleon's soldiers. Goya's attitude, not only in the plastic or pictorial, but in the psychological realm as well, must be recalled. By not representing the faces of the firing soldiers, Goya achieved a more inhuman, impersonal, and prophetic feeling of horror. The rhythm of the soldiers' bodies is unified in their forward movement, their eyes trained on their targets. Corporeality and perspective are fully attained, but the minimizing of details and the uniformity of movement give the figures a certain tragic doll-like character.

On the other hand, a variety of movements, attitudes, and sentiments reigns among the men about to be shot. Their countenances recall the expression of Goya's other figures revealed without pretense at their supreme hour. One man brandishes his fists in anger, while another, in a gesture of defeat, bends earthward. A third covers his face with his hands; still another challenges the uniformed executioners with a haughty stare. But the one who is most courageous on facing death flings his arms open, offering himself for his country. In contrast to the dark background, his opened, white shirt yields the brightest and most luminous note of the composition, attracting the first glance of the spectator.

The horror of the scene is increased by the grave procession of men awaiting the fate being suffered by those immediately before the rifles. A mound of bodies—already cadavers—between pools of blood in the foreground additionally intensifies the horror. As instantaneous as the impact of the theme is that of Goya's range of color. Here the paintings of the Quinta del Sordo are anticipated in the predominant ochers, siennas, grays, and dark maroon, contrasted with white, yellow, and red. In the background, the city is silhouetted against a tormented sky; it is separated from the foreground by a mound rising in contour toward the left. The simplicity of technique, summary but not sketch-like, recalls the boldness seen in some of Goya's fresco decorations, as, for example, those of the Church of San Antonio de la Florida.

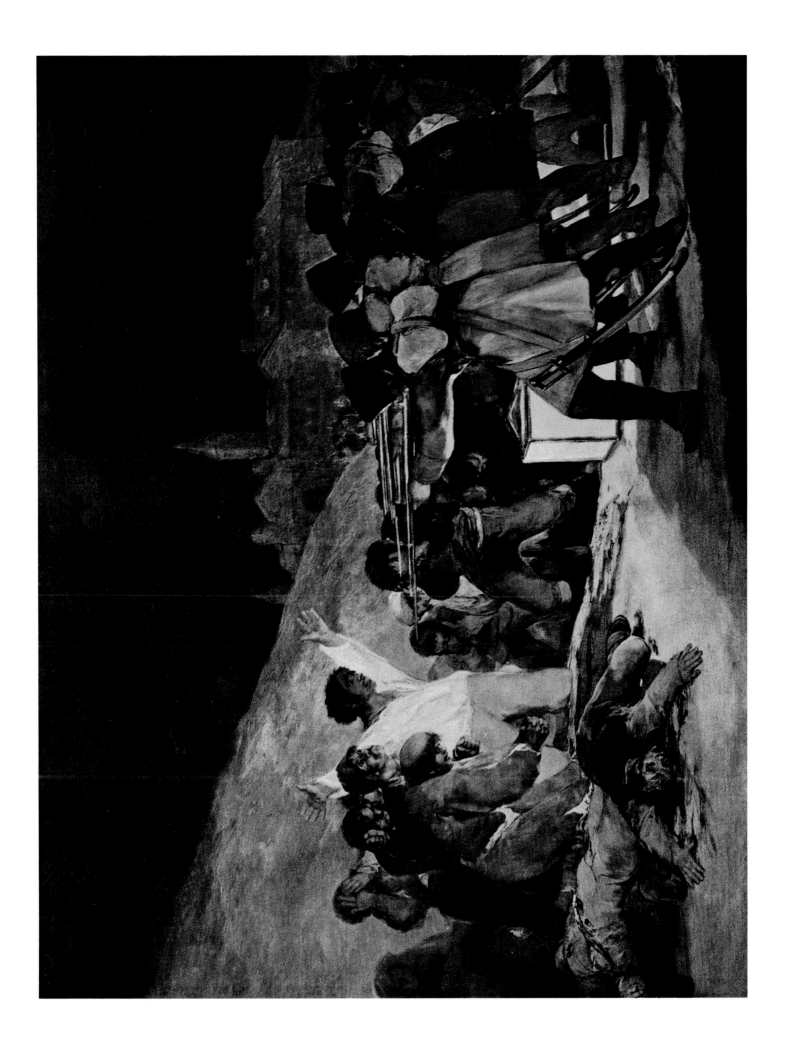

Painted c. 1814

PORTRAIT OF SENORA SABASA GARCIA

Oil on canvas, 28 × 23″

National Gallery of Art, Washington, D.C. (Mellon Collection)

This portrait of a young woman must have been executed during the second decade of the nineteenth century. It presents certain affinities with the portrait *Doña Isabel Cobos de Porcel* in its conception of form, grasp of the figure, range of color, and suggestion of volume. The face exhibits great purity of line. Clarity of form and of each element has been carefully presented, yet the realistic factor has not been accentuated beyond the degree that is normal for a painter of Goya's outlook. A more summary technique may be seen in representing unequivocally the quality of the flesh tones, the accomplished strokes of headdress and clothing, and the ringlets falling upon the sitter's forehead. Interest in painting and brush stroke yields a comparatively free appearance with an excessively faithful rendering of the tactile qualities of the materials included here. The lace of the mantilla is simply alluded to by a regular ornamental design and by a general feeling of the lightness produced by its transparency and texture; in the lower area may be seen the more intense strokes of white pigment which Goya left clearly apparent, not wishing their outlines to be confused with those of neighboring strokes. The triangular shawl is similarly rendered; within it are longer brush strokes that make rhythmically parallel lines against a darker background, thus giving relief to the forms.

Contrarily, the quality of the sleeves and the visible hand is exactly that of the surfaces represented. Shadows of a bright greenish-gray produce a sensation of depth, while simultaneously modeling volume. The background is of an opaque maroon hue. While this tone facilitates a contrast, it produces a certain neutralization that is translated in the very discreet effect of color harmony and in the particular unity giving character to this portrait. In Goya's portraits, it is interesting to observe how background tints having exciting or calming effects were used to attain the "magic of surroundings" referred to in the artist's letters.

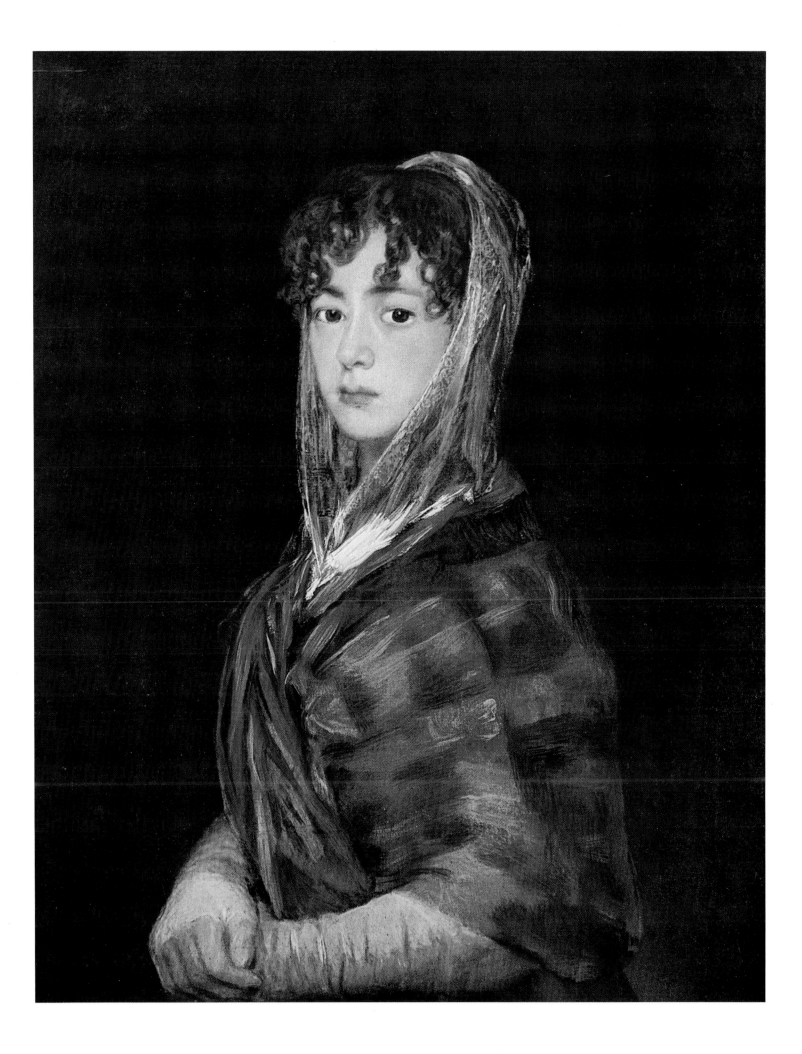

Painted c. 1815

PORTRAIT OF A WOMAN DRESSED IN GRAY

Oil on canvas, 40¹⁄₂ × 32⁵⁄₈″

The Louvre Museum, Paris

In conception of form and appearance, this portrait is a prototype of others painted by Goya at the termination of the Napoleonic invasion. It does not possess the beauty of other female Goya portraits, but there is in the figure of this woman a restful temperament that harmonizes very well with the greenish-gray dress and the cold range of color imposed by these hues. The excellence of plastic beauty in this instance surpasses the possibilities of the modeling. Indeed, the extraordinary quality of the grayish-maroons and violet-toned reflections in the background establishes a unique harmony with the quiet hues of the dress and the rosy whites of the flesh tones. The discreet and yet intense drawing of the form—in the turgid bosom amply filling the low bodice and in the rounded arms—is also balanced by this particular coolness of color.

Moreover, the drawing is aesthetically dominated by subtleties in qualities of the materials. These subtleties do not, however, as frequently happens in Goya's art, destroy the tactile values of the painting in itself. These may be seen particularly in the lace collar trimming the décolleté neckline, or in the long gloves covering the arms but leaving the fingers exposed. The head seems drawn with extraordinary strength. It is painted with the thick and regular impasto that Goya had begun to use around 1800 as a replacement for his earlier technique of greater fineness and *sfumato* qualities. The large black eyes, and the black hair in short ringlets on the temples, animate the solid structure of the face, its contour firmly drawn against the background at the left. In summary, this Louvre portrait magnificently illustrates Goya's great talent as a portraitist.

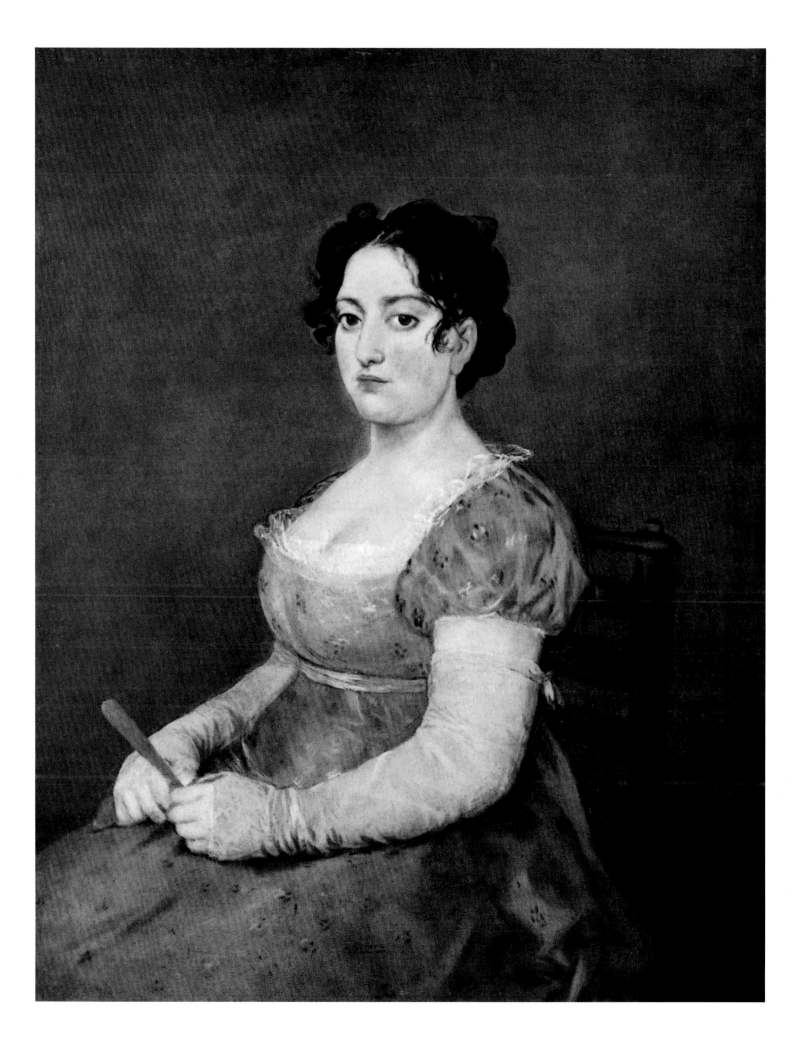

Painted c. 1815

THE INFANTE DON SEBASTIAN GABRIEL DE BORBÓN

Oil on canvas, 56³/₄ × 41³/₈″

Collection Bardi, São Paulo, Brazil

To judge from the apparent age of the Infante, great-grandson of Charles III, this portrait was probably painted during 1815–16, when Goya produced his last series of court portraits. The Spanish Infantry Royal Guard uniform worn by the small officer—a model adopted after 1814—similarly confirms the date of the portrait. As in other portraits of young boys, Goya here employs a simple technique in executing the head and hands in contrast to the vigor with which the accessories of apparel are rendered. Important in this final stage of Goya's long artistic career is the visual effect produced by the juxtaposition of daubs of color. Textural values are also interesting, as are the resultant very decisive variations in brushwork. The tactile quality demanded in official portraits is seen in such elements of the uniform as the long-plumed hat placed on a background rock.

Foreground landscape segments have been treated with a certain naturalism, Goya here using a technique of masses and reflections identical to that visible in the interesting pair of paintings depicting the production of cannon balls and powder in the Tardienta Mountains. The landscape in the distance evidences a surprising return to the smooth backgrounds of the tapestry cartoons. In establishing a parallelism of contrasts between two pictorial formulas, one employed in the landscape and the other in the model and his brilliant uniform, Goya here obtained a perfect balance.

114

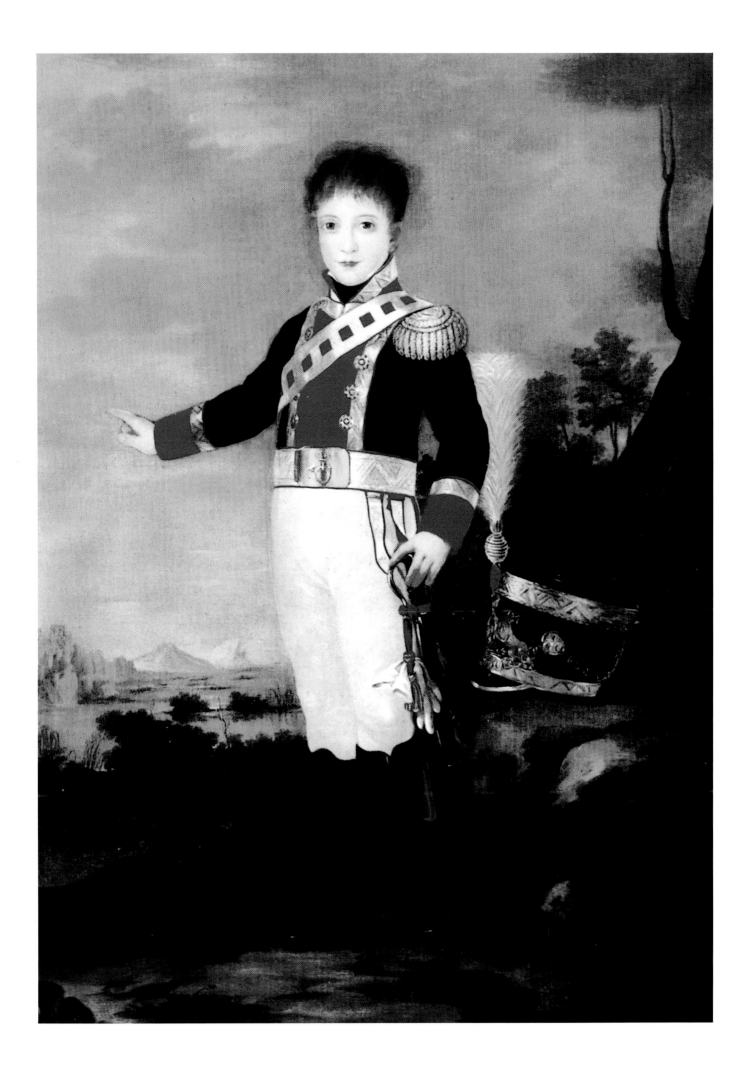

Painted c. 1815

THE FORGE

Oil on canvas, 71⁵/₈ × 49¹/₂"
The Frick Collection, New York

This work is more closely related to the world of Goya's graphic work than it is to his paintings destined for official praise. It is evident that the theme is the dynamism of a group of figures and the contrasts of their forms, rather than the occupation which spatially and rhythmically groups them. The men remain submerged within their types, providing an excellent study for the shaping of violent yet coordinated attitudes. The foremost figure, viewed from the rear, is caught in the instant of raising the large, long-handled hammer for its blow. Facing him his helper grips the piece of metal with tongs. A third figure leans forward to contribute to the activity in his way. The anvil, at the center of this trio, creates admirably a feeling of space, one which actually envelops in its movement the axial projections from the center. The space within which the scene is enacted extends around the group, forming an area that is convincing though devoid of accessories, wholly in submission to the activity in the central scene and its rhythms. Goya's execution creates an effect of full volume, but simultaneously offers a very pictorial and sensual impression of flat relief by the smoothness of its fluid texture. Manet later took this method from Goya, maintaining it until his final years. Some contours are clearly defined with precise linear outlines, as, for example, the legs of the foreground figure and the arms of the man facing him. Other contours, such as those of the upper outline of the facing figure's shirt, are submitted to a treatment designed to mitigate the transition by interpolating an ambiguous area between the texture of the fabric and of the flesh. Shadows are placed in a precise and realistic manner, contributing to the feeling of space. Goya executed this painting during the years 1810–15, shortly before he began his works of genius, the decorations of the Quinta del Sordo.

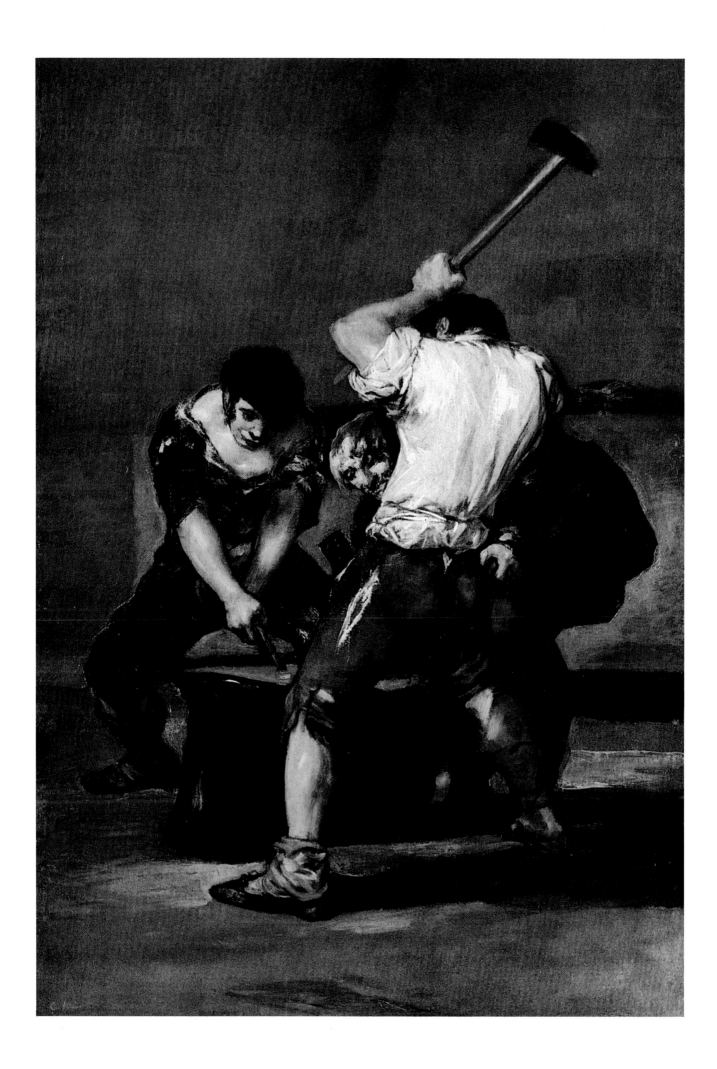

Painted 1815

PORTRAIT OF DON MIGUEL DE LARDIZABAL

Oil on canvas, 29³/₄ × 25³/₄"

National Gallery of Czechoslovakia, Prague

The portrait formula of this painting follows the one established by Goya. A half figure is presented, with a document held in the right hand, and the left arm encircling a bicorn hat. The sitter is shown in military dress coat, rich in gold fringe, lace inserted at the neck, and a decorational sash traversing his chest. He looks forward resolutely, with a bold, and, above all, unswerving expression. Once again the gentleman clearly emerges as he is seen by Goya, the portraitist. This royal minister has been thoroughly and completely characterized: vigorous, impulsive, and doubtlessly a man of action. The face, with its forehead fringed by upright, unkempt, black hair, offers a prodigious grasp of actuality. The glance, though full of decision and self-assurance, is not without some hint of conviction or trust in luck.

Pictorial values are entirely subjected to the theme, though they nevertheless resurge with a profound humanity. The play of colors and tones in the lower area is extraordinarily rich in sensitivity. Volume is rendered with impressive power, despite the somewhat vaporous softness of the body's contours from the neck to the elbows. The attraction of the sitter's face, its roughness refined by an accustomed authoritative bearing, is enhanced by the light which falls directly on the features.

Modeling is absolutely correct; vigorous blendings of successive shades from the highlight of the cheekbones to the ear, though drawn with but slight detail, are painted with great strength, as are also the thick, raised eyebrows. Some areas are left a bit unclear by Goya, thus giving the impression of a brilliant spot, as in the neck scarf. Goya simplifies ornamental details of the outfit, as in the bordered waistcoat. But he brings into service all factors to give maximum force to the idea and personality of the man portrayed.

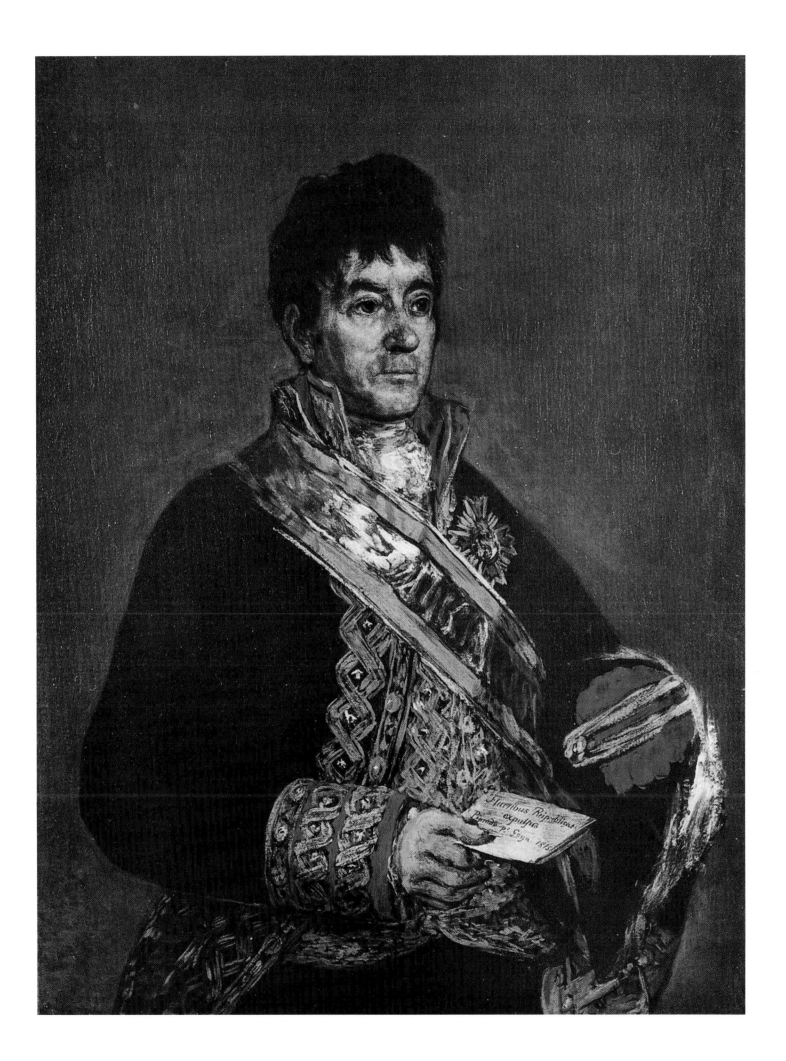

Painted 1819

THE LAST COMMUNION
OF SAN JOSÉ DE CALASANZ

Oil on canvas, 98³/₄ × 70⁷/₈"

Church of San Antonio Abad, Madrid

In this painting, the saint is shown kneeling to receive communion from the hands of a priest. Both figures are almost in profile, seen before a group of the faithful. Goya's power of expression could be proved solely by reference to the admirable faces of these secondary figures. In their heads, which seem quite closely to approximate those appearing in Goya's demoniac compositions, the feeling that they here convey is nevertheless entirely opposite, and reflects intense beatitude. Hues are not uniform but vary with individual temperaments; expressions of hope, repentance, or faith are seen in faces that are, in turn, contrite, serene, or filled with emotion.

Maximum emotional power is concentrated in the central figures, particularly in that of the saint. The lowered eyelids in the face of this ascetic, whose hard life was spent in consecration to divine service, appear to make meaningful the weariness of this old man at the threshold of death. The figure of the priest is also deeply stirring. Like a character from Goya's first period (recall, for example, those seen in the triangular accessory paintings at Muel and Remolinos), he seems literally shaped by the spiritual weight of the ceremony. In Goya's art, manifestation of the sacred frequently emerged as something fearful that humbles rather than comforts.

In technique, this work is closely related to others of the period. However, there is no dissolution of form, nor scarcely of execution, though the latter is sufficiently rapid and synthesizing. Fluidity is preserved among the different parts, and a special interest is given to the surfaces. Moreover, three-dimensional effects are successfully achieved. In total impression, the forms also have something of the softness noticed in the paintings of the deeds of the second and third of May, 1808. This is an effect that might derive from emotional and artistic traits, but could perhaps also be due to the painter's age and state of health. In works of this same period, particularly in those of the last decades of Goya's life, extreme simplification of detail and tremulous execution undoubtedly resulted from lack of a firmness of hand.

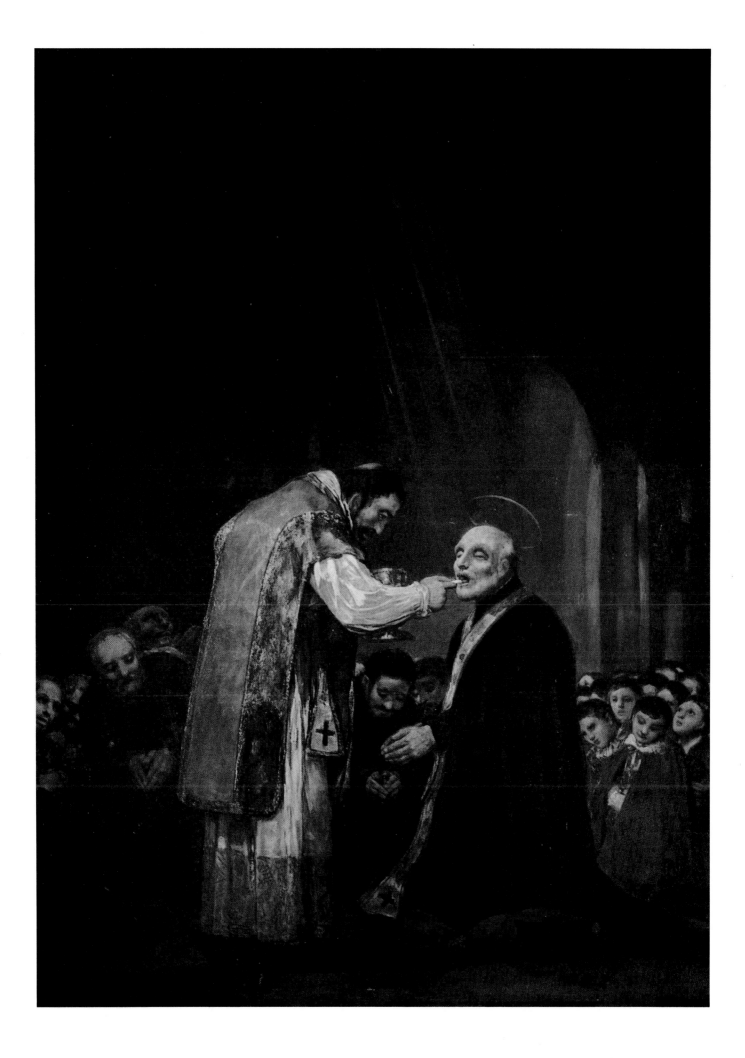

Painted c. 1820

PREACHING MONK

Oil on wood panel, $12^1/_4 \times 10^5/_8''$
Alte Pinakothek, Munich

This panel, also known as *Women in Prayer*, is part of a series that evidently was executed after 1819. The narrative character of the scene illustrates some of the ideas that tormented Goya during the last years of his life. The background is a pure abstraction of cloudy tones, thus giving greater interest to the separate pictorial parts. A few women appear in the foreground, seated or kneeling on the ground below the dark mass of a monk in prayer. The whole assumes an aura of mystery and witchcraft comparable to the compositions of the Quinta del Sordo, to which it bears a very close technical relationship. The composition was prepared with daubings slightly varied in hue, the linear form drawn with dark tracings that are considerably marked where the rhythm so requires.

Diffused qualities are predominant in this work, in which Goya did not go into detailed representation or undertake the rendering of fine shades in the different materials. Rather, the essential form of the subject was drawn rapidly and with intensity, yielding a singular rhythmic unity of form.

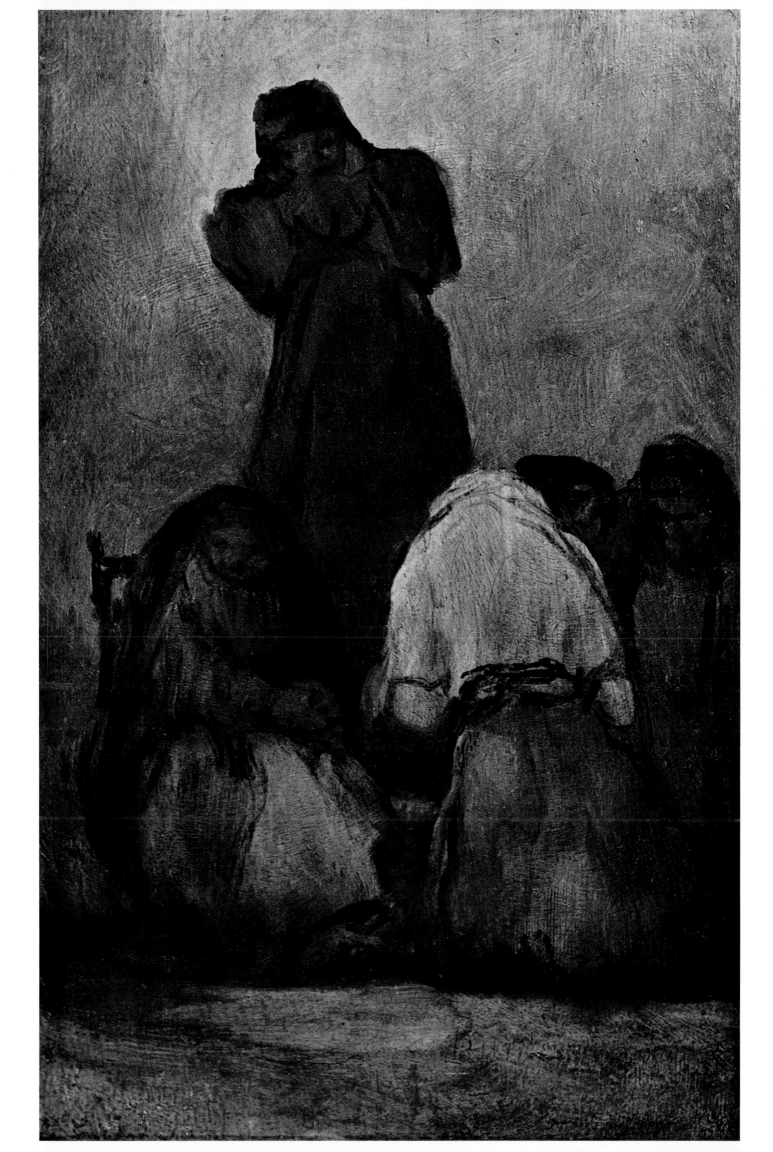

Painted 1821–22

THE WITCHES' SABBATH

Oil on canvas, $55^1/_8 \times 172^1/_2''$
The Prado Museum, Madrid

In this composition from Goya's country house in the outskirts of Madrid, the theme seen in the *Caprices* and in the painting in the Lázaro Galdiano Foundation recurs anew. However, the subject has now developed into a much more pictorial composition than the preceding creations had been. The surrounding elements all disappear, including even the atmosphere—whatever might be considered external. A dense multitude of demonized creatures are heaped together, forming a mass which extends completely through the horizontal format. Standing out against this background are the shapes of a he-goat (personifying Satan) and of a white-hooded witch, who is seen from behind. Color is here reduced to some swift notes, sunk into an almost two-color pattern of black-and-white with intervening sepias. Individual differences are scarcely decipherable in the mass of figures forming the sabbath assembly, except at the sides of the group where full-length female shapes are seated. There is a similar crouching position affected by all the figures, as though they seek to approximate animal forms. Countenances and facial grimaces express horror and the power of the unknown—as it were, the devil's presence stimulating the subhuman beings.

As in other paintings of the series, there is an exact balance between iconographic intention and technique, significance being sought by both means. Violent brush strokes rendering blobs or broken tracings each correspond to an element of form, though they also lend the forms a degree of disintegration. This procedure is revealed as particularly useful in shaping figures formed out of small segments, each of which is realized with a single stroke of the brush. An example of this technique may be seen in the fingers of the hands and in the toes of the bare feet, and also in the contours of the ears and in the lines of the chins. Turbulence of expression reaches its climax in the sinister figures of the central group.

Painted 1827

THE MILKMAID OF BORDEAUX

Oil on canvas, 29¹⁄₂ × 26³⁄₈″

The Prado Museum, Madrid

This admirable female figure painted by Goya in 1827 seems to us his farewell to life. In the painting, as in the woman, may be seen the painter's love for beauty. The model's somewhat inclined posture in itself possesses a graceful rhythm. Lines defining contours, such as those of the two directions taken by the transparent shawl that crosses her bosom or those undulating along the ample skirt forms, give additional prominence to smooth, curving rhythms. The painter was attracted to the half-figure. Thus his canvas has partly the character of a portrait and partly the character of a poetic, not clearly determined, figuration. The noble regularity of the Bordeaux milkmaid's features here goes beyond the popular and somewhat archaic traits perceptible in so many of Goya's female types. In *The Milkmaid*, the painter evokes a feminine image that, while not ideal, nevertheless characterizes that aspect of beauty considered traditional in the classic cultures. Almost in profile, the warm-complexioned, large-eyed woman exhibits all of life's intensity. It may be said that if Goya so stressed material values in this painting, it was precisely in order to underscore his feeling for the earthly reality of the image.

The technique is of great interest. Short brush strokes and dense impasto, together with a mixture of tints, somewhat dissolve the form, while introducing very suggestive luminous values. Shadows of some strength, and linear accents created by contrasting tones, contribute to the sensation of truthful immediacy that emanates from this work. Details of the milkmaid's dress have received as painstaking a treatment as the flesh itself, as may be seen particularly in the extraordinary shawl that reverberates with iridescences. A very beautiful qualitative rather than color-keyed contrast is created between the figure and the sky. The smooth and delicate blues and whites of the sky withdraw to a great depth by virtue of the strength of form and materiality of the figure. The landscape between the milkmaid and the light-bathed background of sky is supported by intense white areas whose reflections penetrate into the interior of the form, unifying it with its surroundings.

This work, which Goya painted at the age of eighty-one when he was already near death, may be considered one of his most eminent and representative canvases. If the tremor of his hand intervened in execution of particular qualitative intensities, this cannot be construed as a defect, since the artist successfully transformed such difficulties into positive factors.

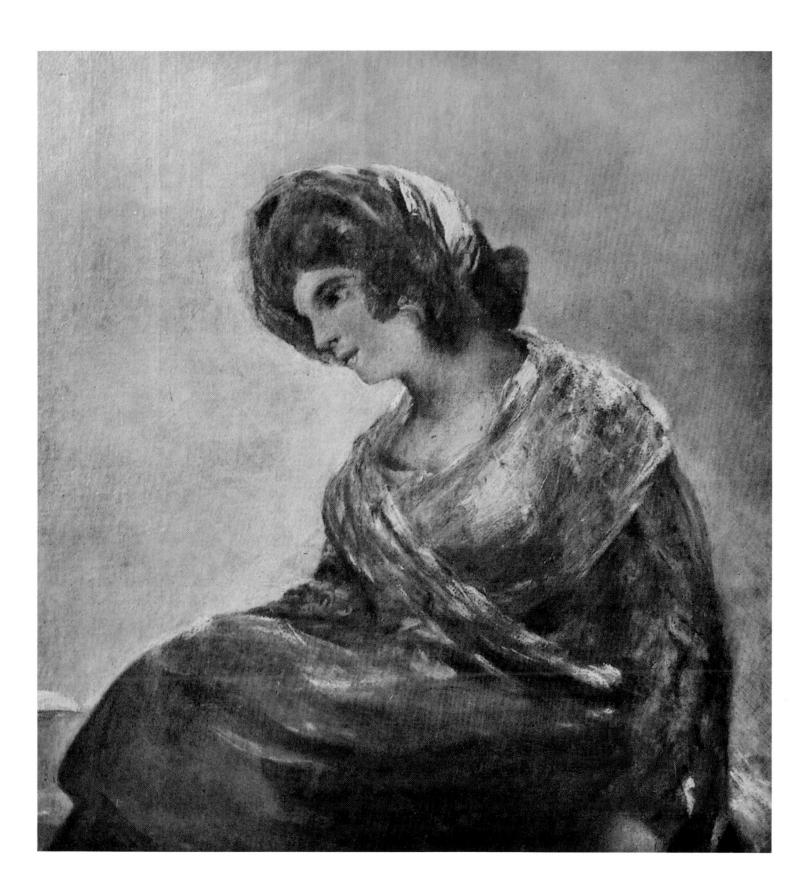